EISENSTAEDT
ON
EISENSTAEDT

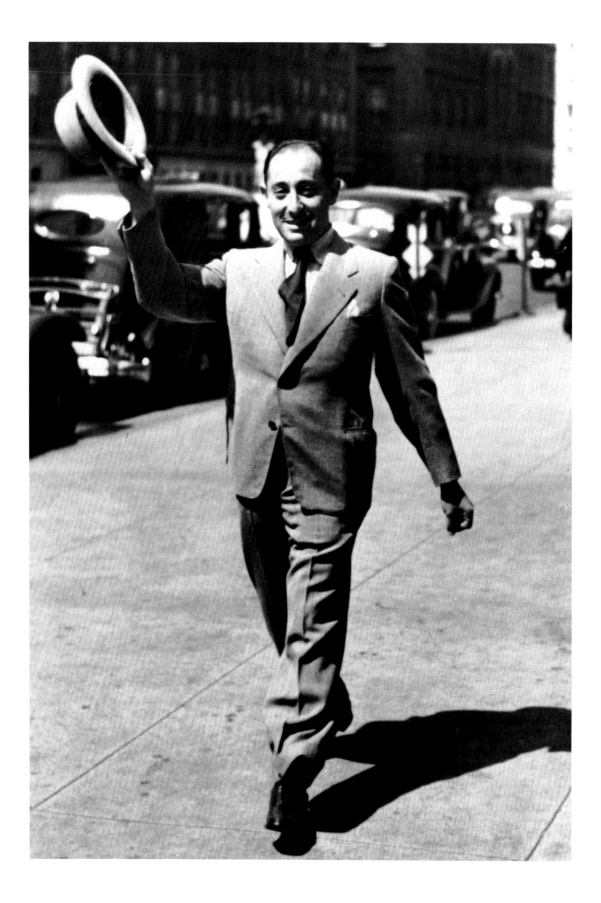

EISENSTAEDT ON EISENSTAEDT

A Self-Portrait

PHOTOS AND TEXT BY ALFRED EISENSTAEDT

Introduction by Peter Adam

ABBEVILLE PRESS PUBLISHERS

NEW YORK · LONDON · PARIS

Editor: Anne Hoy
Designer: Howard Morris
Produced by Andreas Landshoff

Frontispiece: copyright © 1942 Hans Knopf

Library of Congress Cataloging-in-Publication Data
Eisenstaedt, Alfred.
 Eisenstaedt.
 1. Photography, Journalistic. 2. Eisenstaedt,
Alfred.
 I. Title.
 TR820.E38 1985
 770′.92′4 84-20362
 ISBN 0-89659-515-3

BBC film co-produced by M. M. Chanowski Produc-
tions and Andreas Landshoff Productions, Holland.

Revised edition

10 9 8 7 6 5 4 3 2 1

First published in the United Kingdom by
BBC Publications.

Introduction

Following is the introduction to the first edition, published in 1985.

Alfred Eisenstaedt was born in Dirschau, West Prussia, in 1898, the son of a merchant. He moved with his family to Berlin in 1906, where he remained until Adolf Hitler and the National Socialists came to power. In 1935 he settled in New York, where he still lives and works.

Eisenstaedt has been called "the father of photojournalism," the first to practice candid-camera photography consistently. During the sixty years of his photographic career—first in Germany for the Associated Press and then in America for *Life* magazine—he has, in his own words, "photographed more people than any other photographer." No fewer than 92 *Life* covers have carried his pictures, and he has traveled throughout the world on more than 2,500 assignments. But the cold statistics say little about the formidable record of his work. It is a testimony of events and people who have shaped the contemporary world.

His photographs have appeared in numerous magazines. They have been exhibited in museums and reproduced in books. Some of his most famous ones—such as *V.J. Day*—are known to millions of people, though few may even know the name of the man who took that picture on August 15, 1945.

This book is based on a conversation with Alfred Eisenstaedt in the winter of 1981 during the making of the documentary film series "Great Master Photographers" for BBC Television. We were sitting in a cluttered, windowless room on the twenty-eighth floor of the Time-Life Building in Manhattan, an office much like any other. But in it were hundreds of stacked yellow cardboard boxes containing a historical record of a unique kind.

The boxes were labeled in bold handwriting— "Germany," "Great Americans," "Children," "Great Englishmen," "Musicians," "Miscellaneous," and so on. Undisturbed by our television camera or the natural chaos of literally hundreds of thousands of photographs, Eisie, as he is lovingly known in the building, fished out some pictures and started to talk about them. Jumping effortlessly from a concert in Berlin of the 1920s to some events during the last war, from the elegance of St. Moritz to the poverty of Ethiopia, he painted a panorama of encounters and experiences that is unequaled. He needed little prompting; his memory was almost flawless. Remembering every name and date, every circumstance in the taking of the photographs, his eyes lit up and his hands gesticulated. A natural actor, a cheerful clown, he relished his anecdotes, some of them hilarious, others grave. Only a little over five feet tall, Eisenstaedt, then eighty-three, showed no sign of his age. His energy and determination seem boundless. Henry Luce, his editor-in-chief at Time, Inc., once said, "Eisie is as strong as an ox and as agile as a mountain goat." During the hours of our conversation he also proved to be one of the liveliest witnesses to our times I have ever encountered.

PETER ADAM

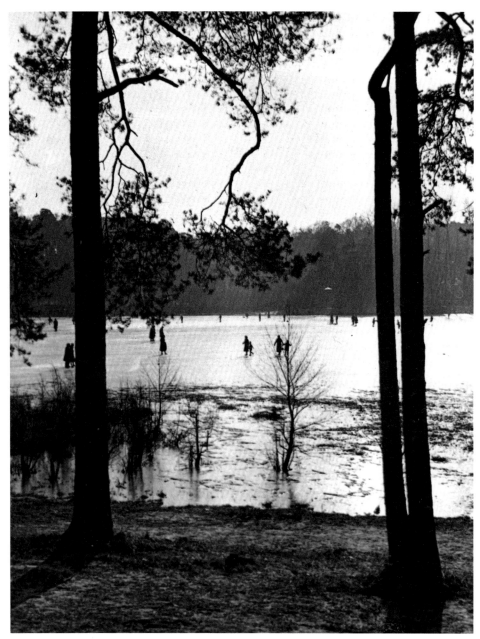

GRUNEWALDSEE, BERLIN, 1913

*I have thousands of pictures, and I will show some of them here.
Many became very famous, other have not been seen, but all are of
some significance to the sixty years of my photographic life. My first
encounter with photography was very simple. It started in 1912
when an uncle of mine gave me for my fourteenth birthday an
Eastman Kodak Folding Camera No. 3 and I began photographing
right away. One of my first pictures was of the Grunewald Lake.*

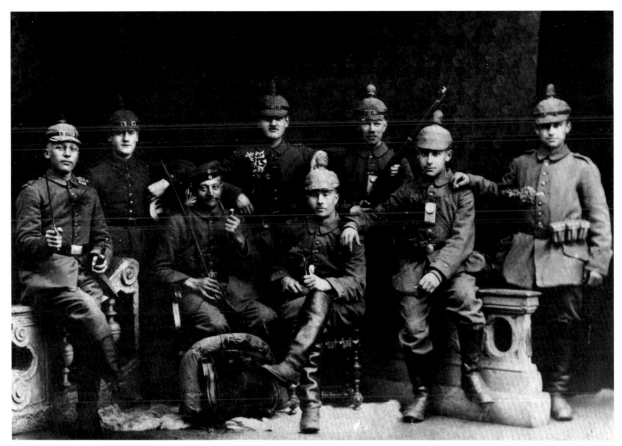

GERMAN SOLDIERS, NAUMBURG, 1916

I took quite a few pictures at that time, but they are all lost. In 1916 I was drafted into the army. I was seventeen years old. Here is a picture of me with my comrades. I was the only one who was not killed. I was shot in the legs, which saved my life.

After the war I started to take photographs again, but I had to make a living and I was selling belts and buttons for a wholesaler in Berlin. I saved all my money to buy photographic equipment. In 1927, I went with my parents on a vacation to Johannisbad in Bohemia, and there I photographed a woman tennis player. It was in August or September in the afternoon and there were long shadows. Tourists were walking around and sitting on benches watching. I took only one picture of the scene, with a Zeiss Ideal Camera, 9 x 12 cm with glass plates. I developed it back home in our bathroom. I was rather satisfied when I showed it to a friend of mine. "Why don't you enlarge it?" he asked. And he showed me a contraption of a wooden box with a frosted light bulb inside attached to a 9 x 12 camera, same as mine. The whole thing was fastened to a wall with my glass plate of the tennis player inside. When I saw that one could enlarge and eliminate unnecessary details, the photo bug bit me and I saw enormous possibilities.

After buying the same equipment, I enlarged the picture at home and took it to all sorts of photo magazines. Finally, the editor of the weekly magazine Der Welt Spiegel *said, "I like it. I'll give you three marks (about twelve dollars at that time). Bring me more pictures like that." "Goodness," I said, "you get paid for pictures." After all, it was only a hobby of mine and I had no idea that professional photography existed.*

Two weeks later I brought him a second picture, of an old lady with white hair in the Anhalter Bahnhof (the main railroad station of Berlin). It was so steamy inside that the sun rays created a halo around her head. The picture looked very beautiful. They accepted that one too.

The editor told me, "If you want to succeed in photography you should look at the work of Dr. Erich Salomon." Salomon was at that time the great political photographer of European conferences and worked for the publishing empire of Ullstein. He photographed all the outstanding statesmen, and I admired his work tremendously. He was like a god to me. I knew that Salomon used an Ermanox camera and I bought one too. The year was 1928, and I joined the Associated Press on a free-lance basis.

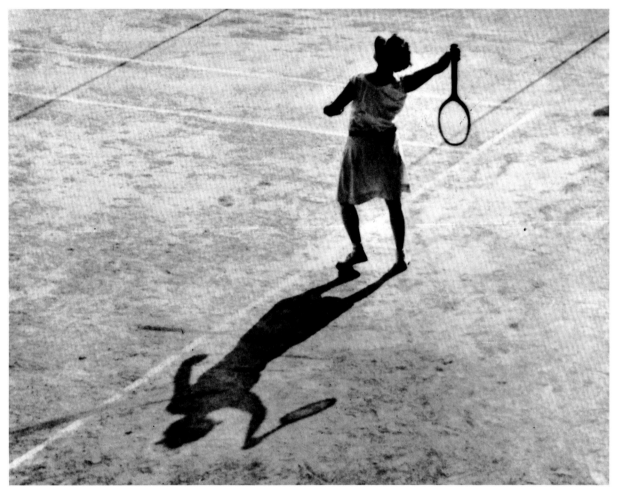

FIRST PICTURE SOLD, JOHANNISBAD, BOHEMIA, 1926

My first assignment was a prayer meeting of the Salvation Army. I worked with an Ermanox camera on a rickety tripod. I had never used the Ermanox before; as I had no exposure meter, naturally I didn't know what the exposure was. Suddenly a woman fell to the ground right in front of me. I took the picture. This photograph and others I made at the meeting were published in Der Welt Spiegel. *A famous writer of that time, Fred Hildebrant, wrote the text to them. It was my first photo essay.*

Of course, I was still selling belts and buttons because I had to make a living. One day my boss said to me, "Look, you are such a bad salesman." "I know I am bad, because I am not really interested in selling buttons. I have other interests. I want to do photography." "What do you call it? Photography?" He looked at me as if I were going to cut my own throat. The idea of photography was as new as flying.

 So I left the firm on the third of December, 1929, and became a professional.

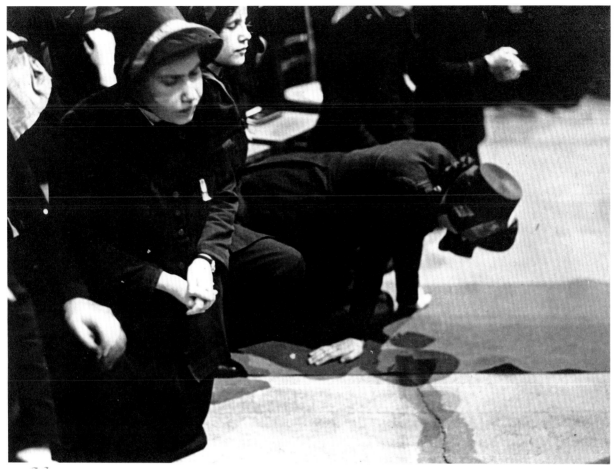

SALVATION ARMY, BERLIN, 1928

Six days later I traveled to Stockholm to photograph the Nobel prize for literature being given to Thomas Mann (seated, first row, behind speaker). Behind him sat the great Swedish novelist Selma Lagerlöf, who also won a Nobel prize, and all the great scientists. Thomas Mann later addressed the audience—among them the royal family of Sweden, King Gustav V, Crown Prince Gustav Adolf, Crown Princess Louise, and her daughter Princess Ingrid, who later became queen of Denmark.

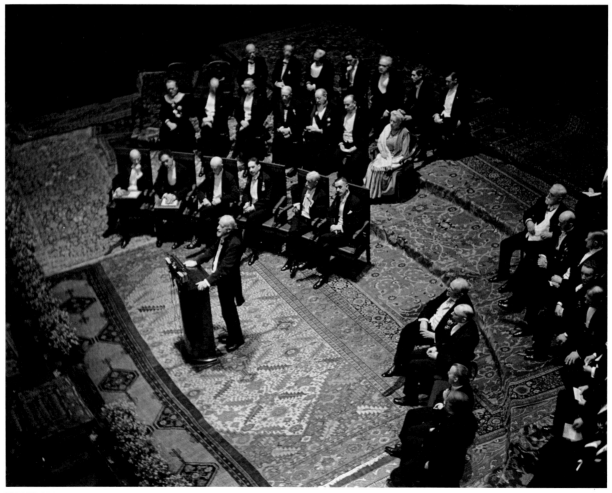

NOBEL PRIZE FOR THOMAS MANN, STOCKHOLM, 1929

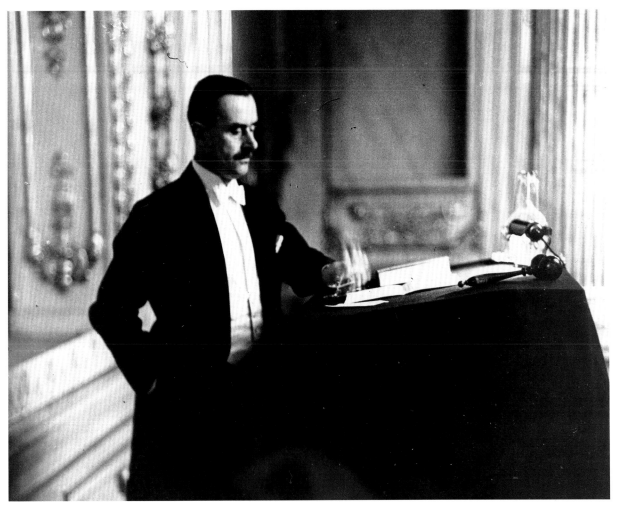

THOMAS MANN, STOCKHOLM, 1929

*After the session I photographed Thomas Mann delivering his
acceptance address.*

My second assignment was a disaster. I had to go to Assisi to photograph the wedding of King Boris of Bulgaria to the youngest daughter of King Victor Emmanuel of Italy. I traveled with 240 pounds of luggage. You must remember I did not have a Leica at that time, and cameras were heavy with all the glass plates. Also, we were always expected to look proper for the occasion, dark suits and black tie, not like today. The pockets of my tails and dinner jacket were specially reinforced to carry the plates and steel holders.

When I arrived in Assisi, I was so fascinated by the pageantry, watching King Ferdinand of Bulgaria trotting along with the longest nose in the world, Mussolini and all the other important people, I forgot all about the assignment and never took the picture of the groom and the bride. When I returned to Berlin there was an uproar, but they couldn't fire me because I was still only a free lance. I kept on working and I made good. Several years later I was able to photograph the royal couple.

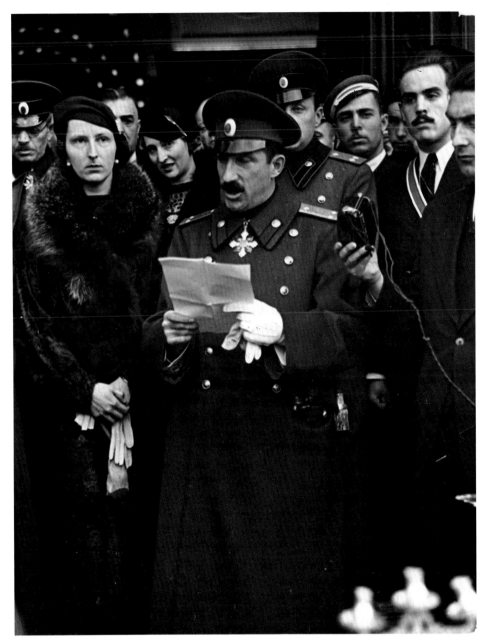

KING BORIS OF BULGARIA AND HIS WIFE, SOFIA, 1934

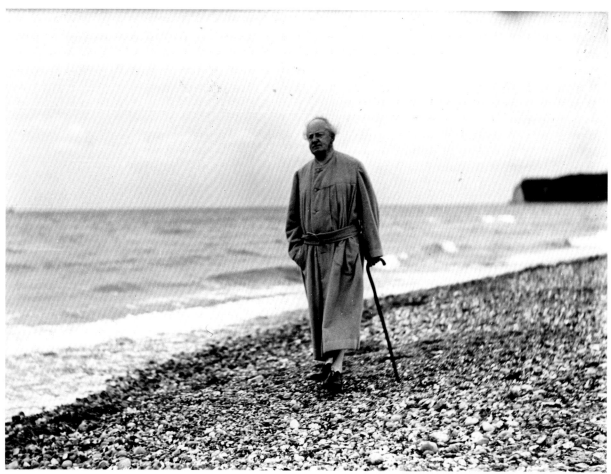

GERHART HAUPTMANN IN HIDDENSEE, BALTIC SEA, 1931

In 1931, I was sent to Hiddensee, a small island in the Baltic Sea, to photograph the great German author Gerhart Hauptmann. I caught him walking on the beach—it is not a posed picture—he looked like the personification of Goethe.

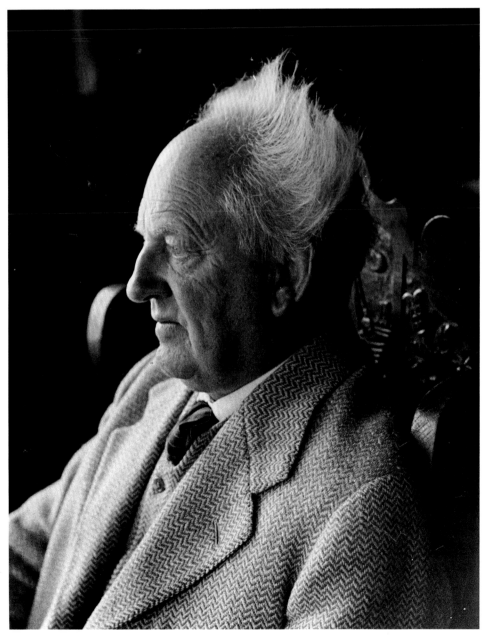

GERHART HAUPTMANN, 1931

This picture was taken with a Miroflex camera, 2¼ x 3¼ cm. I was surprised that it came out so sharp. It is a formal portrait. When I look at it now, I am startled how bad the composition is. That white spot in the background—this wouldn't happen today. I always look at the background first; there should be nothing distracting.

LION FEUCHTWANGER, HEINRICH MANN, CARL ZUCKMAYER, BERLIN, 1931

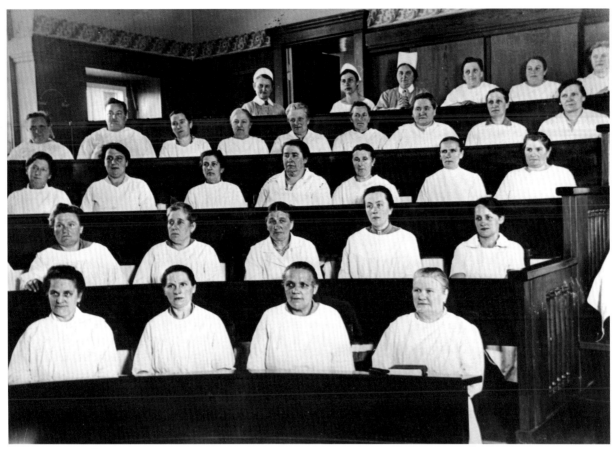

MIDWIVES, NEUKÖLLN HOSPITAL, BERLIN, 1931

◁ *During these years I traveled quite a bit throughout Europe and did photographic essays. This photo of three of the leading German authors was made at a writers meeting.*

Here some German midwives are being taught about new procedures in their trade. This picture was published in several German magazines.

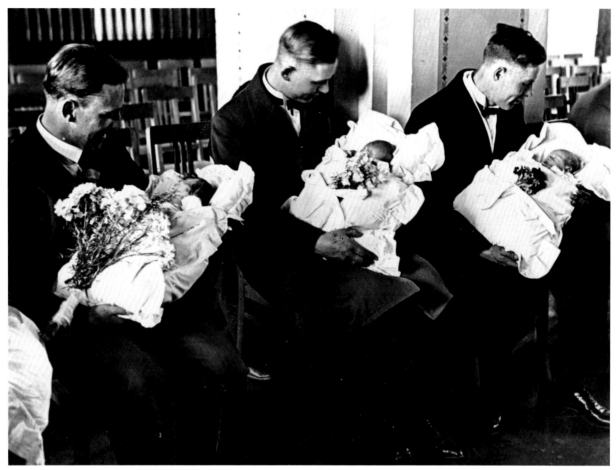

CONFIRMATION, NEUKÖLLN HOSPITAL, BERLIN, 1931

*At the same time I also photographed the christening of three babies
with their proud fathers.*

A "Society" for collectors of toy railroads. Elderly men with stiff collars ▷
playing with toy trains.

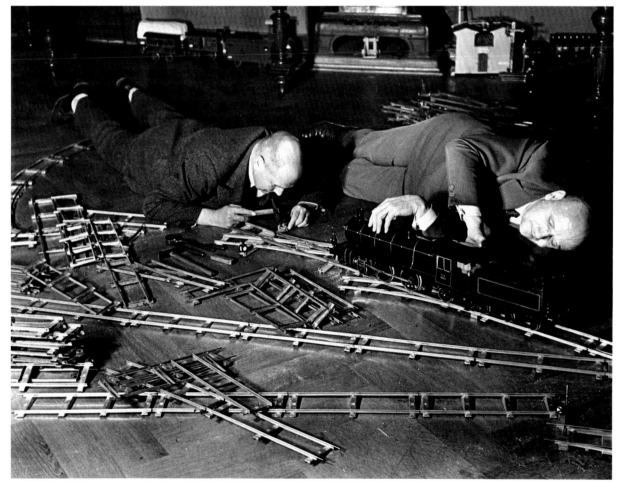

TOY TRAIN SOCIETY, BERLIN, 1931

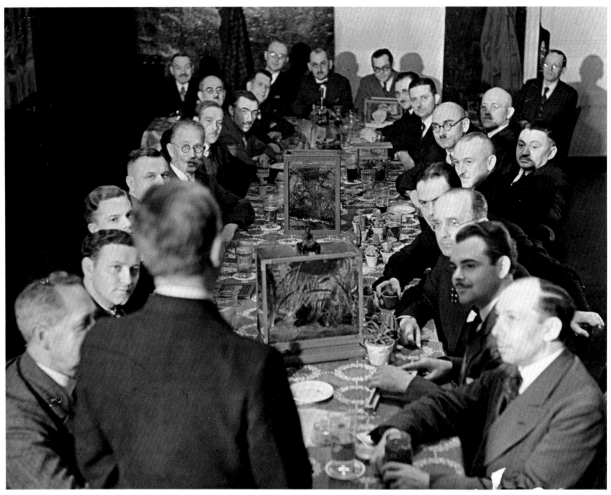

AQUARIUM SOCIETY, BERLIN, 1931

At that time every good German had an aquarium with tropical fish. This picture shows a meeting of the Berlin Aquarium Society. I rarely took many photographs of the same subject because I could not carry a lot of those heavy glass plates. Only if someone moved would I take another one.

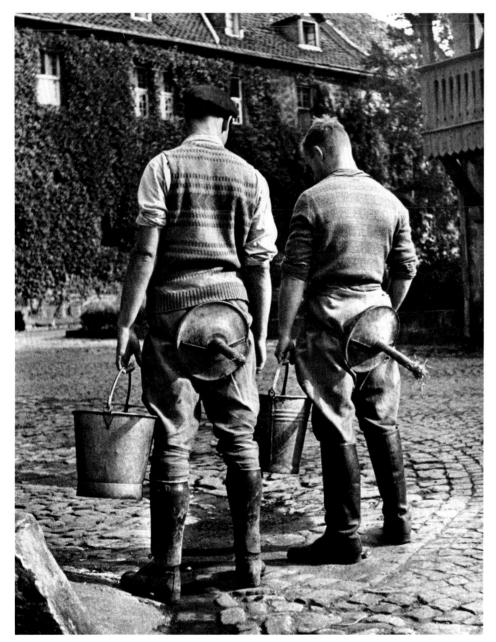

AGRICULTURAL SCHOOL IN EAST PRUSSIA, 1934

I traveled to East Prussia to photograph an agricultural school. Some students had their milking stools attached to their bottoms; they looked like Nazi storm troopers with their boots.

23

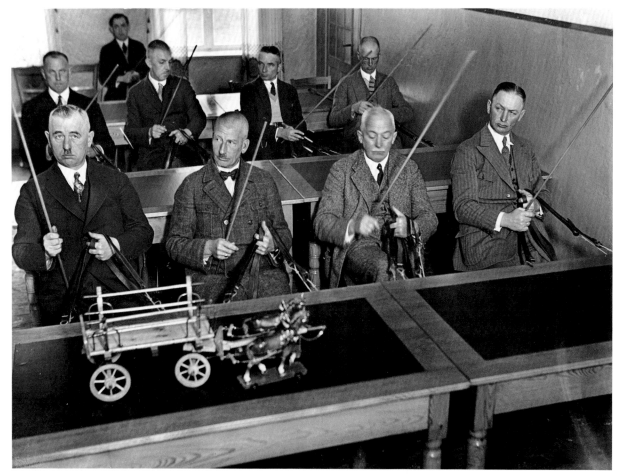

PRUSSIAN COACHMEN LEARNING HOW TO HOLD THE REINS, NEUDECK, EAST PRUSSIA, 1934

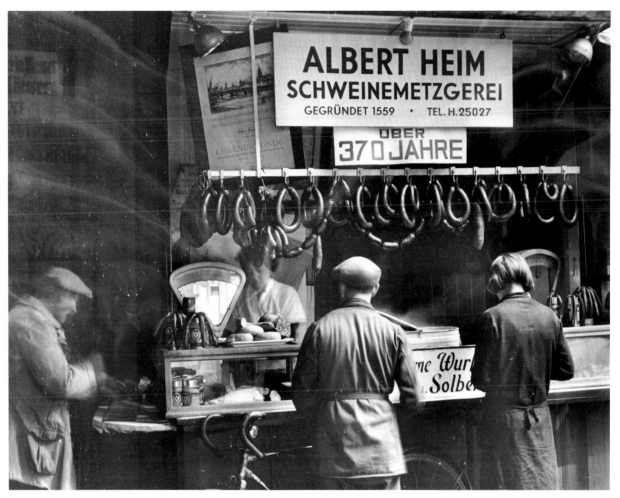

FRANKFURT AM MAIN, 1933

In Frankfurt am Main, I took a picture of the butcher's shop where frankfurters were invented. It was 370 years old and called Albert Heim. These photographs show a Germany a long time gone. One cannot imagine those people and things today.

◁ *I also photographed coachmen learning to hold the reins of their horses. They are not the Prussian Junkers themselves, only coachmen, but with these stiff collars they look like their masters.*

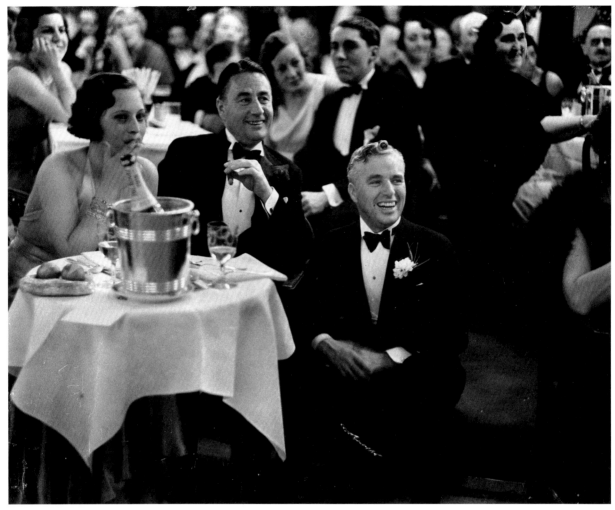

SIDNEY AND CHARLIE CHAPLIN, PRESSEBALL, BERLIN, 1929

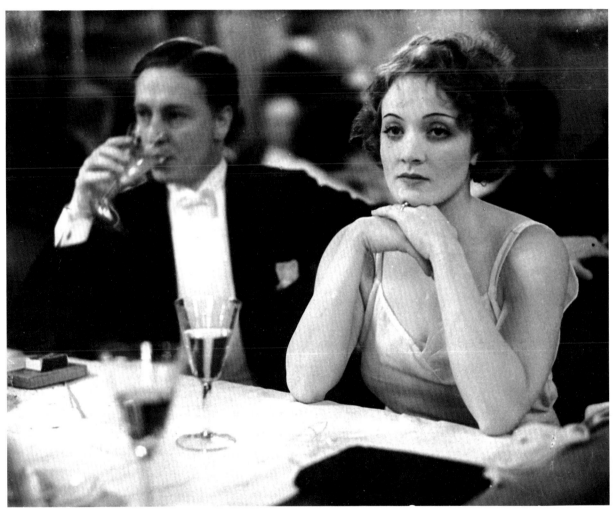

MARLENE DIETRICH AND HER HUSBAND ERICH SIEBER, BERLIN, 1929

◁ *I also photographed a lot of actors and Berlin society. Here is a picture of Charlie Chaplin with his brother Sidney attending the Presseball in Berlin.*

At another ball I shot this picture of Marlene Dietrich, with her husband, Erich Sieber.

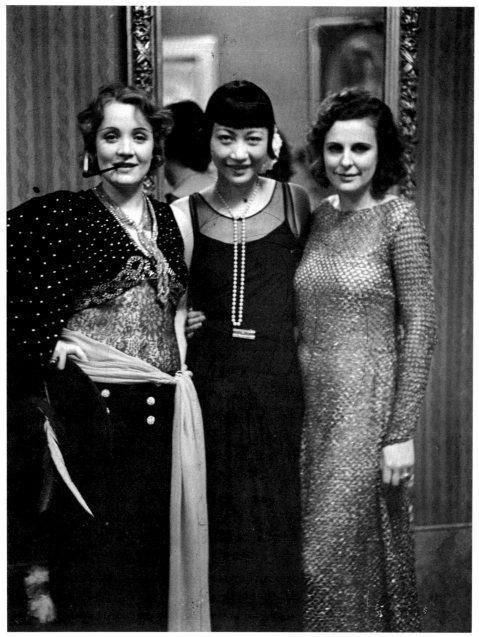

MARLENE DIETRICH, ANNA MAY WONG, AND LENI RIEFENSTAHL, AT AN ANNUAL ARTIST'S BALL.
BERLIN, 1928

*I first photographed her at the famous Reimann Ball, which
everybody went to. She had just finished the movie* The Blue Angel.
*This picture was published time and time again. Leni Riefenstahl
was at the time an aspiring actress. Later she directed* Triumph of
the Will *and* Olympiade, *the 1936 Olympic Games film, for Hitler.*

I photographed Leni Riefenstahl again in 1980 when I visited Germany. She was very shy, and it took me a long time to persuade her to be photographed after all the publicity about her involvement with the Nazis. I was very much taken with her charm and by her talent. At age 72 she became a diver to make underwater pictures of coral reefs, and she published two books of her photographs of African tribes.

LENI RIEFENSTAHL, MUNICH, 1980

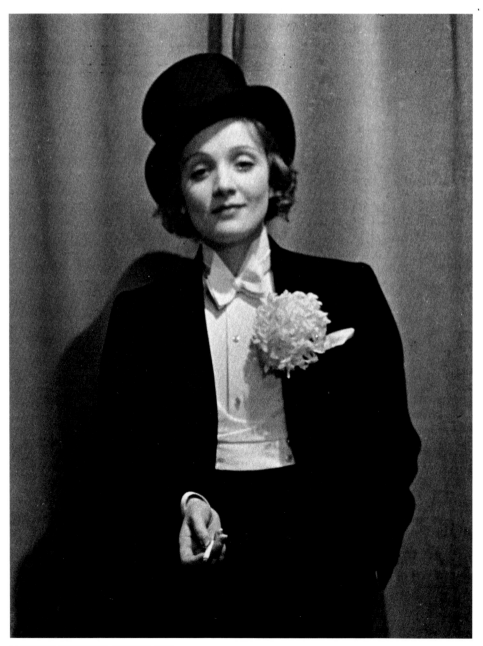

MARLENE DIETRICH, BERLIN, 1929

At the annual Presseball in the famous Hotel Adlon, Dietrich wore tails and pants, which was unheard of at that time. She had to stand very still because the exposure was always between half a second and a second. If someone moved I had to take the picture over again.

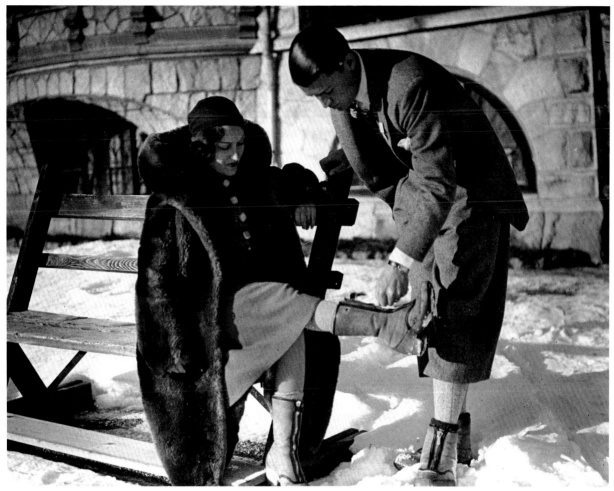

GLORIA SWANSON AND MICHAEL FARMER, ST. MORITZ, 1932

In St. Moritz, I photographed Gloria Swanson and her fourth husband, on an ice rink and . . .

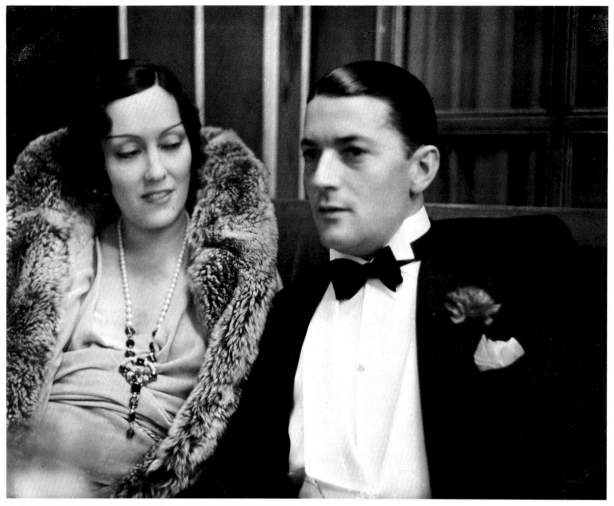

GLORIA SWANSON AND MICHAEL FARMER, ST. MORITZ, 1932

. . . later at a ball in the Palace Hotel.

At the ice rink of the Grand Hotel was a waiters school where young ▷
apprentices learned how to serve drinks to the mostly English guests
who used to have lunch and cocktails there. The waiters were all
on skates. I did one smashing picture of the skating headwaiter. To
be sure the picture was sharp, I put a chair on the ice and asked
the waiter to skate by it. I had a Miroflex camera and focused on
the chair.

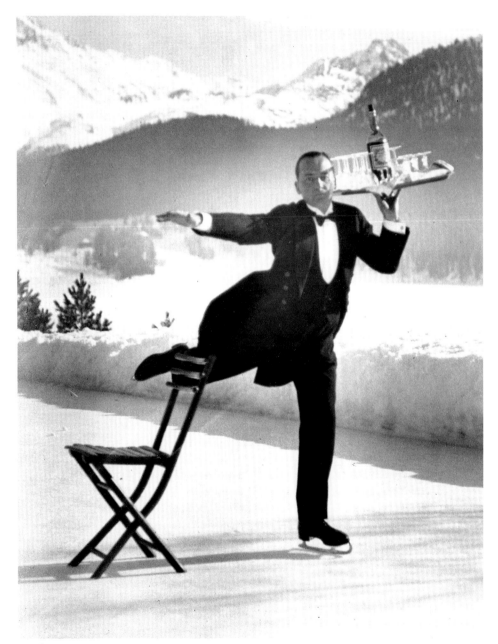

RENÉ BREGUET, ST. MORITZ, 1932

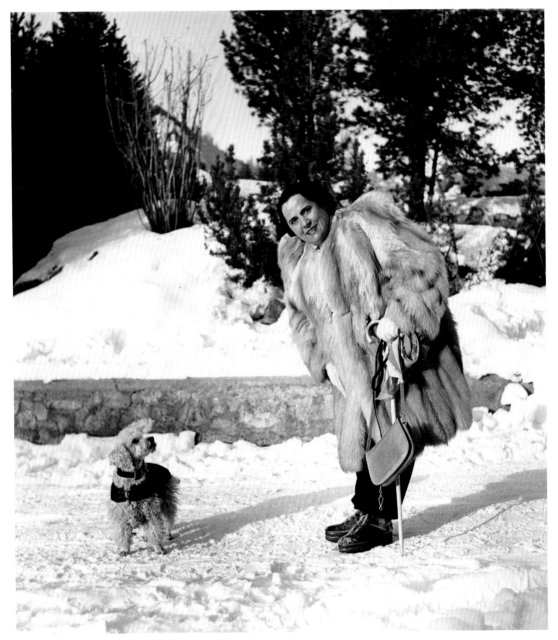

POODLE AND HER MISTRESS, ST. MORITZ, EARLY 1930s

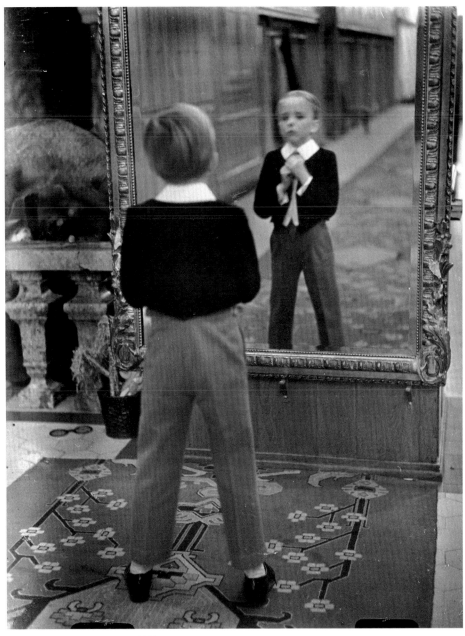

ENGLISH BOY, ST. MORITZ, 1932

◁ Also in St. Moritz, I photographed a funny, overclad, over-fur-coated lady. She must have been more afraid than her poodle of catching cold.

I also caught a young Eton-type boy looking in the mirror of the Grand Hotel.

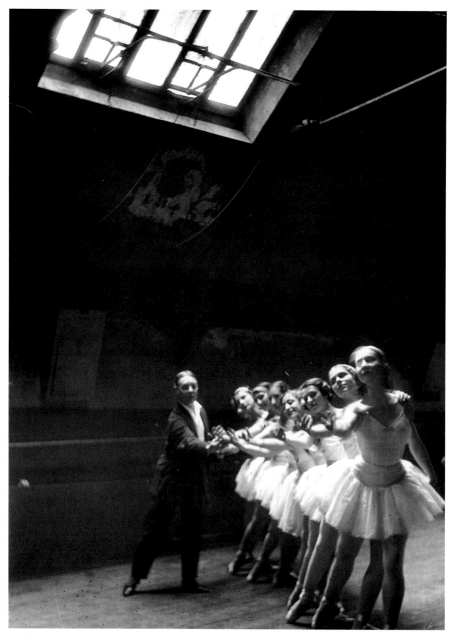

OPÉRA DE PARIS, 1930

*One of my earliest assignments outside Germany was in Paris. I did
not have a Leica yet but a 6 x 9 cm Plaubel Makina, and I still
worked without an exposure meter. Photographing a rehearsal
of Swan Lake at the Paris Opera, I had illumination only through
the skylight of the studio—a Rembrandt sort of light. I used to
look at the old master painters in museums and study their light
and composition.*

Fluorescent light had not been invented—fortunately. It kills all the mood. During a break I took another picture with a simple tripod and some glass plates. Photojournalism had just started, and I knew very little about photography. It was an adventure, and I was always amazed when anything came out.

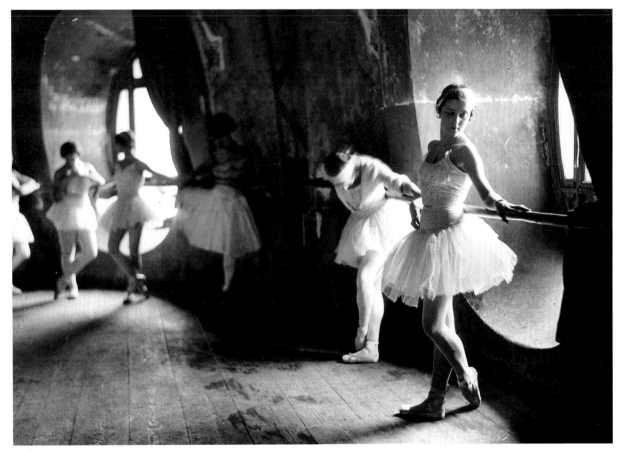

OPÉRA DE PARIS, 1930

In Italy, I photographed a gala evening at La Scala in Milan. This was one of my first pictures with a Leica on a tripod. All those rows of boxes with their little lights and bejeweled audience. It is a pleasing picture, but not The *picture because it has no foreground.*

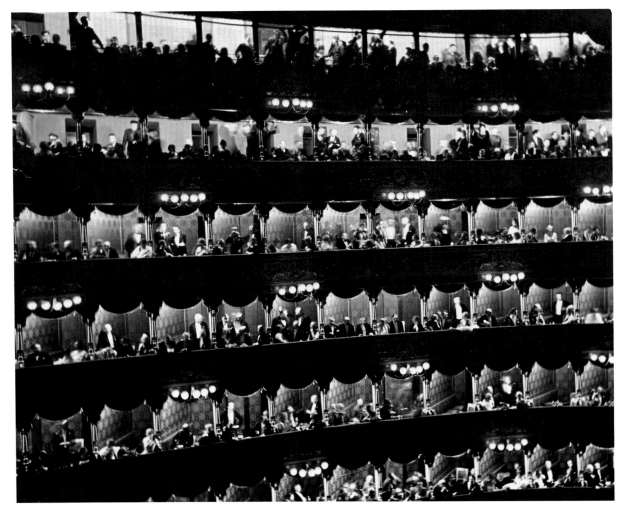

LA SCALA, MILAN, 1934

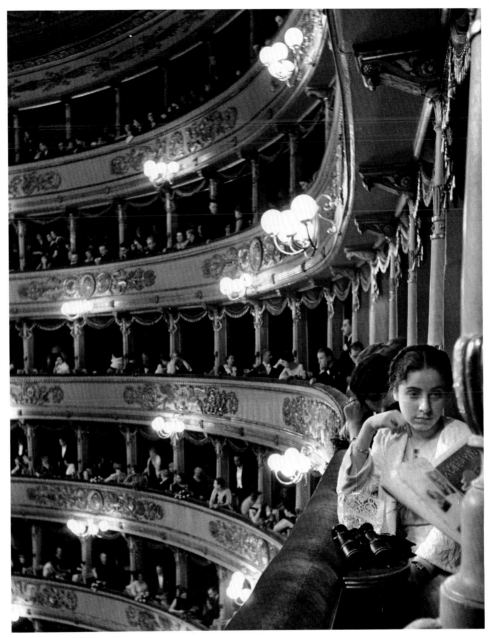

LA SCALA, MILAN, 1934

Suddenly I saw a lovely young society girl sitting next to an empty box. From that box I took another picture, with the girl in the foreground. For years and years this has been one of my prize photographs. Without the girl I would not have had a memorable picture.

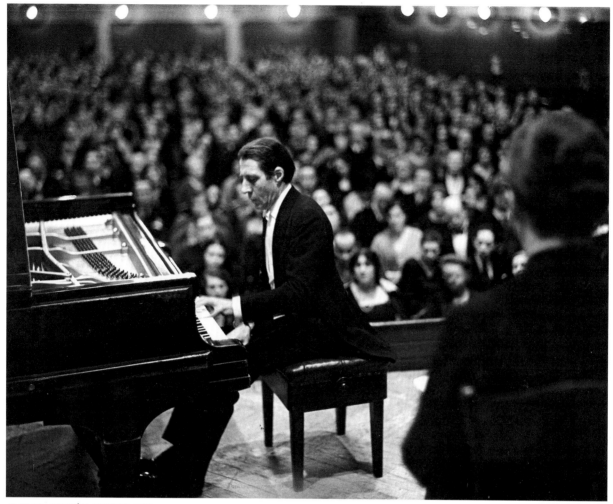

ALFRED CORTÔT, BERLIN, 1932

From childhood I have liked music, and throughout my career I have photographed musicians. This passion started early in Berlin. Many people have asked me how it was possible to take so many pictures of famous conductors, players, and singers without their objecting to it. The answer is very simple. In those days, there was no other photographer doing that sort of thing.

With my Ermanox, I could sit in the first row of the audience and nobody paid attention to me. Sometimes I even sat among the musicians dressed as one of them, my tripod between my legs. A little later I bought an attachable silent diaphragm shutter—it didn't make a click. For nostalgic reasons, I am sorry I did not keep these primitive tools.

This is a photograph of the great Chopin interpreter Alfred Cortôt, which I took sitting on the platform.

I still remember that Furtwängler was conducting Beethoven's
"Fifth Symphony" when I photographed him.

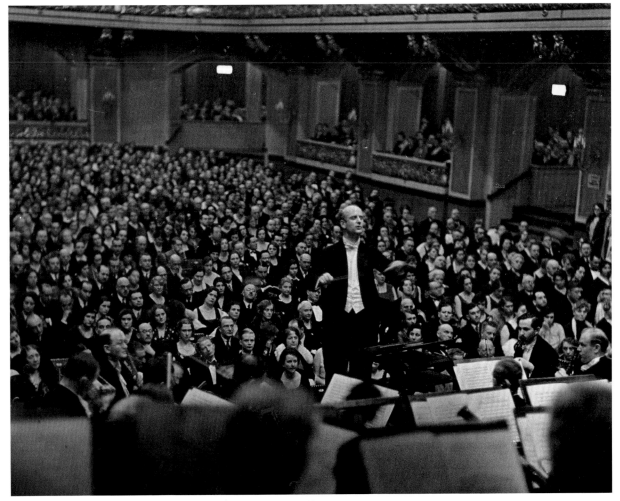

WILHELM FURTWÄNGLER, PHILHARMONIC HALL, BERLIN, 1932

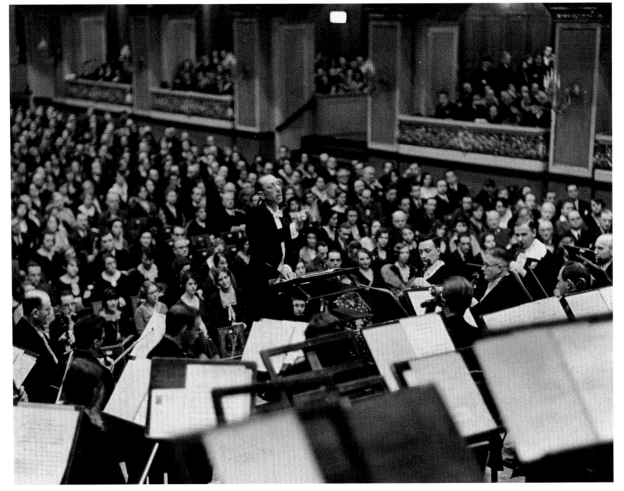

IGOR STRAVINSKY, BERLIN, 1932

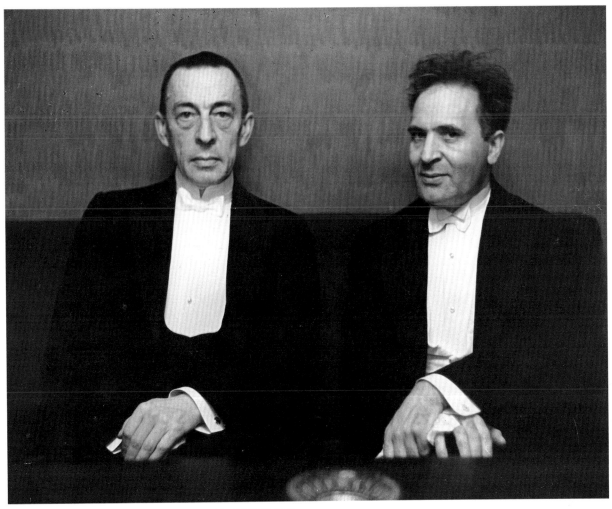

SERGEI RACHMANINOFF AND BRUNO WALTER, BERLIN, 1932

◁ *The fifty-year-old Igor Stravinsky from almost the same position in the same hall. I don't remember what he conducted because I was concentrating so hard on what I was doing.*

In later years photographing became easier for me. I was more accustomed to the camera and could concentrate on the people. Here are the two great musicians before a concert.

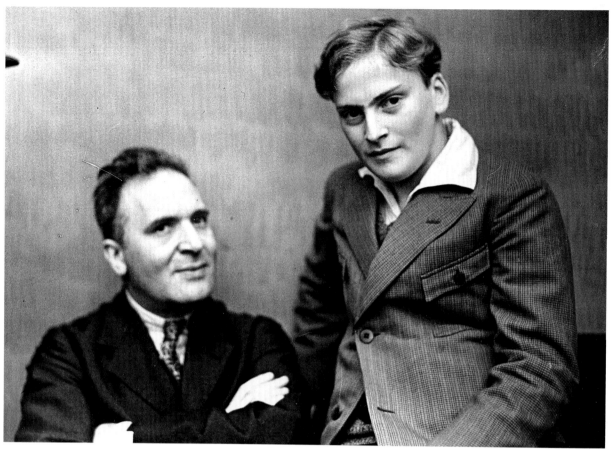

BRUNO WALTER AND YEHUDI MENUHIN, BERLIN, 1932

Menuhin was sixteen at the time.

Three great musicians relaxing during an intermission: the violin virtuoso Nathan Milstein, the pianist Vladimir Horowitz, and the cellist Gregor Piatigorski. Of course, I felt rather important photographing all those famous people, but I was never conceited. It was a job and I was proud doing it. It was a work of love.

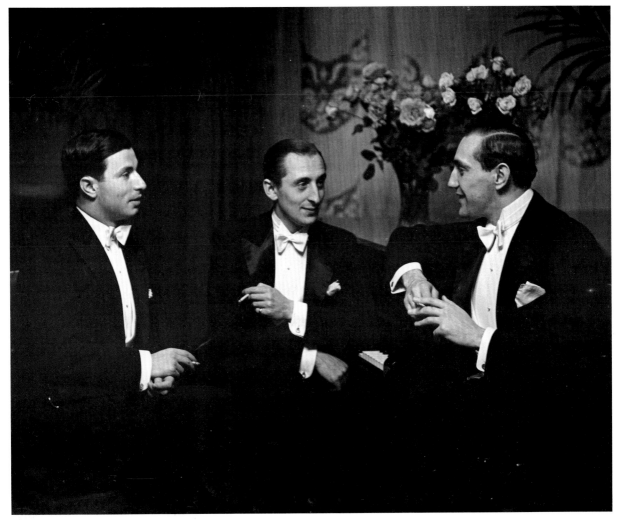

NATHAN MILSTEIN, VLADIMIR HOROWITZ, AND GREGOR PIATIGORSKI, BERLIN, 1932

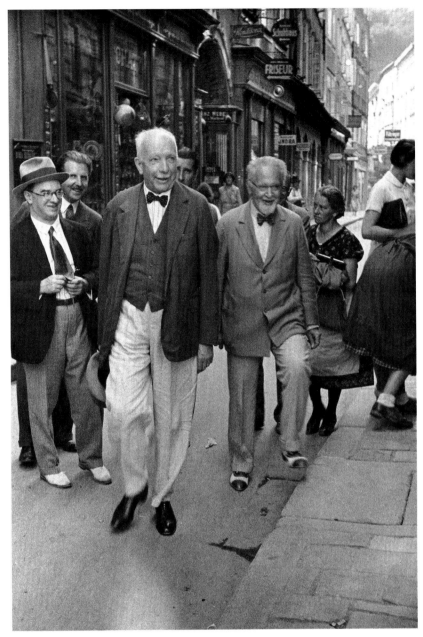

RICHARD STRAUSS, SALZBURG, 1932

I am especially proud to have been able to photograph the composer Richard Strauss . . .

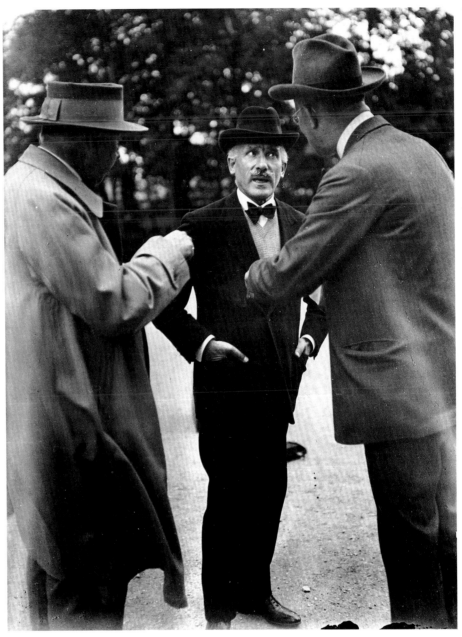

ARTURO TOSCANINI, BAYREUTH, 1932

and Wieland Wagner (right), the grandson of Richard Wagner, talking to Arturo Toscanini.

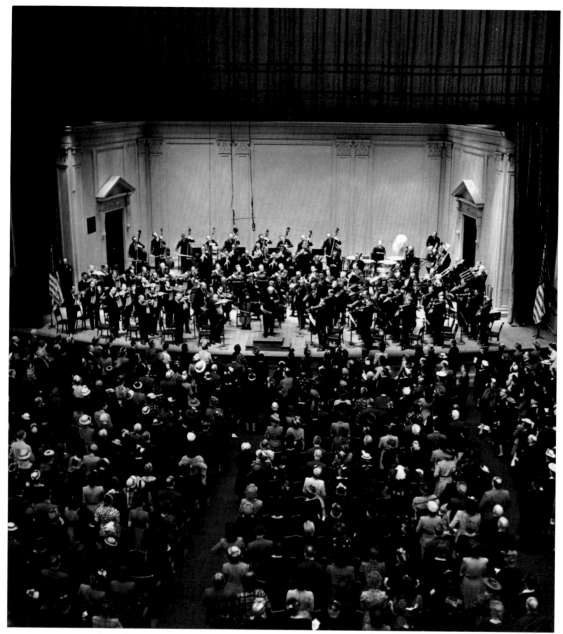

ARTURO TOSCANINI, NEW YORK, 1941

At a concert in Carnegie Hall just after Pearl Harbor, I clicked while Toscanini, facing the audience, the whole orchestra standing, conducted the "Star-Spangled Banner." A historic moment! When I took the photograph to my editors, they asked, "Where are the other pictures?" I had only taken one. I am known at Life *magazine as one of the great undershooters.*

*I photographed the composer of operettas Franz Léhar at his home,
one year before his death.*

FRANZ LÉHAR, ZURICH, 1947

DMITRI MITROPOULOS, MINNEAPOLIS, 1945

I also photographed Dmitri Mitropoulos, the conductor of the Minneapolis Symphony Orchestra, in his home. Everybody told me how difficult the maestro was. When I arrived I heard someone practicing the violin, so I asked Mitropoulos, "Who is playing Walton's 'Violin Concerto'?" He was so impressed a photographer knew music that he became very cooperative. It was the violinist Jasha Heifetz practicing. Walton had dedicated the concerto to him.

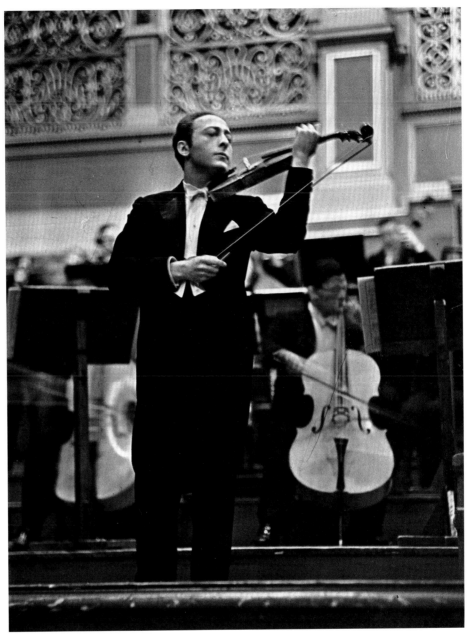

JASHA HEIFETZ, BERLIN, 1932

I had already photographed Heifetz thirteen years earlier.

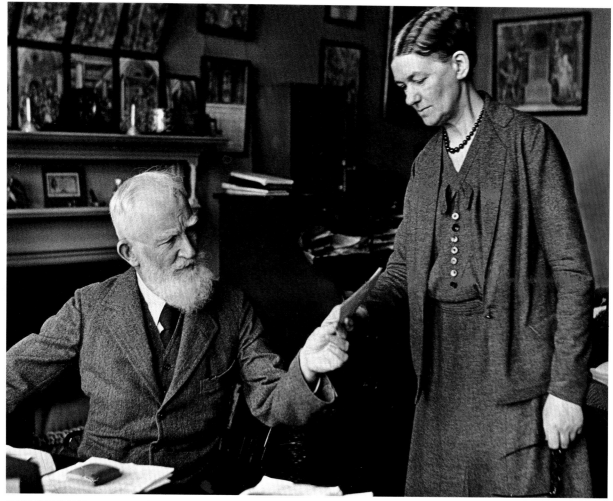

GEORGE BERNARD SHAW, LONDON, 1932

Many of the pictures I took in the early 1930s were published in German and English magazines. In 1932, I traveled to London hoping to photograph George Bernard Shaw. People told me he was very difficult and inaccessible, but I was also told that he was a vegetarian. So I bought a bunch of bananas and sent these, together with a portfolio of my photographs, to his home at Whitehall Court. Two days later I was asked to visit him. He looked through my photographs and said, "You don't have to make me pose, I am a photographer myself."

Shaw was very friendly and did everything I wanted. I wish all people were so cooperative. He had a wonderful old Smith Premier typewriter. I remember it like yesterday. I even remember the house number—it was No. 4.

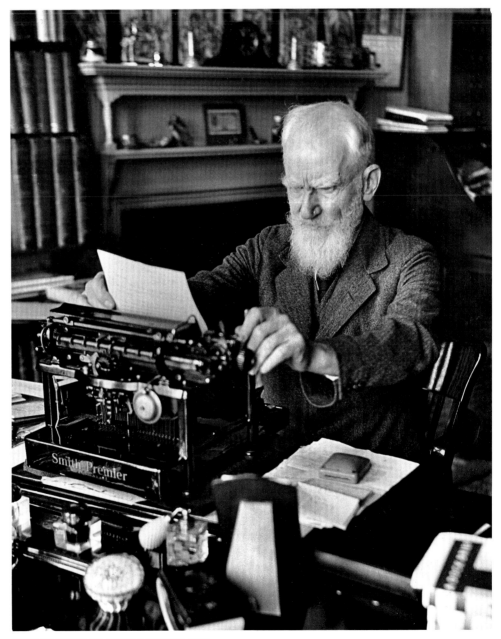

GEORGE BERNARD SHAW, LONDON, 1932

Getting the right angle sometimes requires a little ingenuity.
I am often a bit shy, but the shyness soon disappears when I have a
camera in my hand.

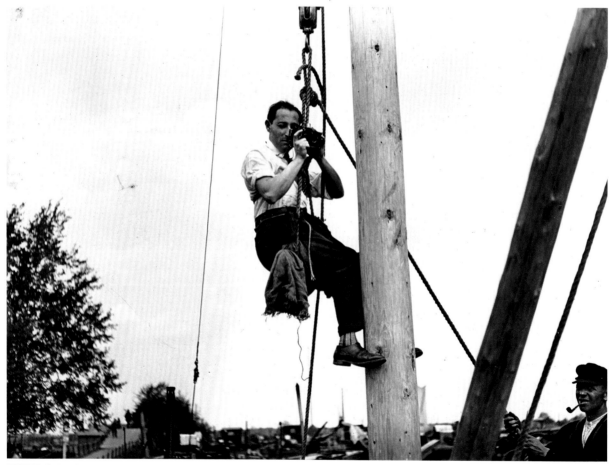

EISENSTAEDT AT WORK, PHOTOGRAPHING BARGES, BERLIN, 1931

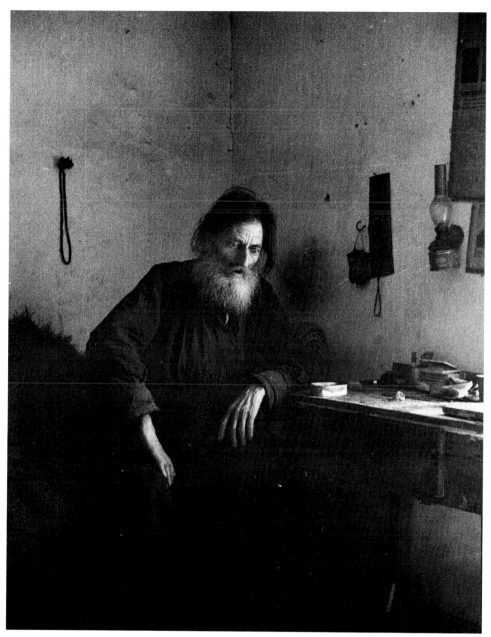

DYING MONK, GREECE, 1934

During a trip to Greece to cover the arrival and visit of the royal family of Sweden, I came across this man at a monastery in Thessaly. The only light came from a little window, and I took six or seven photographs, all hand-held, with a Leica. Only this one came out.

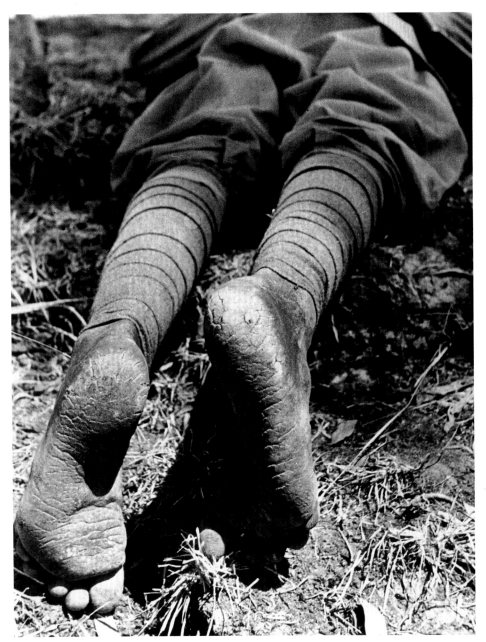

ETHIOPIA, 1935

On the eve of Mussolini's attack in Ethiopia, I took this shot of the Emperor's soldiers on maneuvers. The close-up tells the whole story of a barefoot army.

*When Hitler and Mussolini met on June 13, 1934, in Venice,
Mussolini was the big shot. It was the first meeting between the two
dictators, and the last time Hitler appeared in mufti, before
taking full power.*

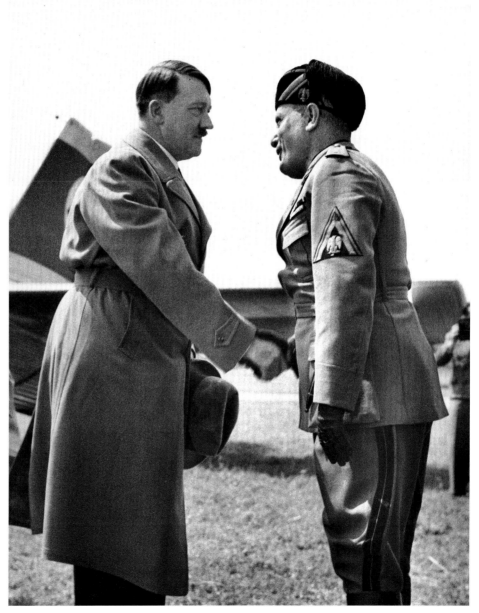

ADOLF HITLER AND BENITO MUSSOLINI, VENICE, 1934

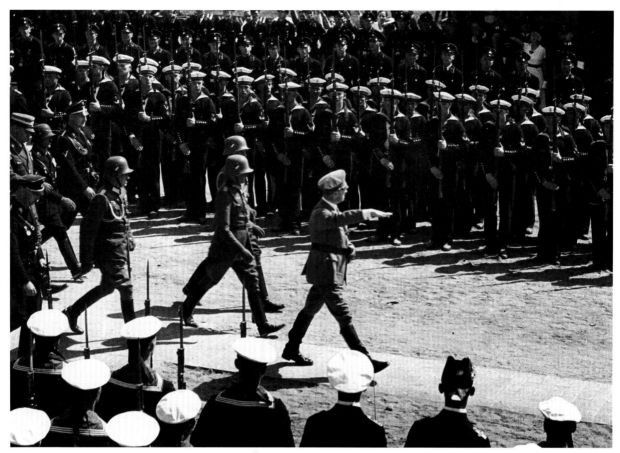

TANNENBERG, EAST PRUSSIA, 1934

Two months later the president of Germany, Paul von Hindenburg, died, and Hitler became Führer of the Reich. At the funeral in Tannenberg he was seen for the first time in the Führer's uniform, strutting along. Behind him (extreme left) walked the S.S. Sturmgruppenführer Heinrich Himmler and all the "Greats" of Hitler's Reich.

The plump Hermann Goering, Marshal of the Air Force, in the funeral procession.

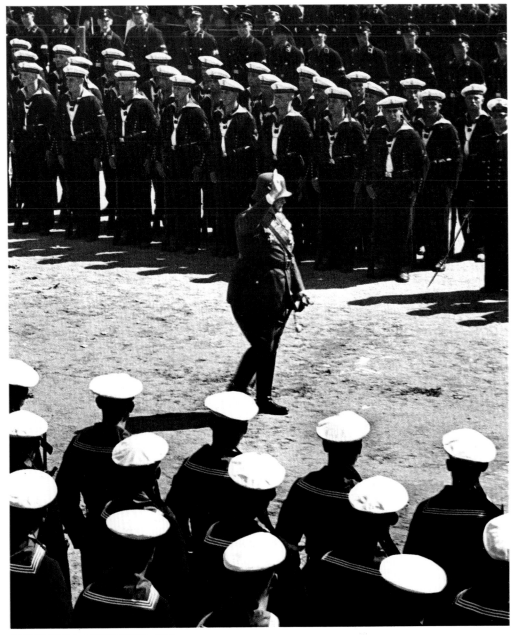

TANNENBERG, EAST PRUSSIA, 1934

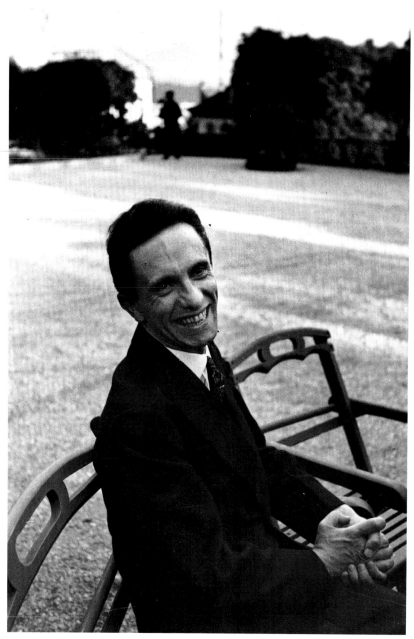

GENEVA, SEPTEMBER 1933

I also covered quite a few international conferences and took many historical pictures. In 1933, I traveled to Lausanne and Geneva for the fifteenth session of the League of Nations. There, sitting in the hotel garden, was Dr. Joseph Goebbels, Hitler's minister of propaganda. He smiles, but not at me. He was looking at someone to my left. This picture has never been published before.

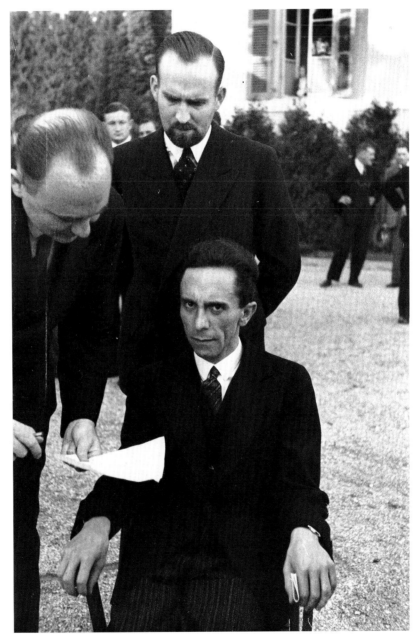

Suddenly he spotted me and I snapped him. His expression changed. Here are the eyes of hate. Was I an enemy? Behind him is his private secretary Walter Werner Naumann, with the goatee, and Hitler's interpreter, Dr. Paul Schmidt. This picture was published many times throughout the world in newspapers and magazines.

I have been asked how I felt photographing these men. Naturally, not so good, but when I have a camera in my hand I know no fear.

GENEVA, SEPTEMBER 1933

I left Germany in November, 1935, and emigrated to the United States. I was lucky because I was still a free-lancer for the Associated Press, so I found work very soon.

Life magazine started a year later. They looked at my photographs and told me, "This is the sort of photography we want." I haven't ever had to change my style. When one looks in Who's Who, it says that I brought the candid camera to America. I don't know if I did, but when I started with Life, it was old hat for me—I had done that sort of work before in Europe. In the States magazines rarely printed pictures for stories. But it was fairly common in England and Europe.

My pictures were in the first issue of Life, and the second issue had my cover picture and photo essay about the Military Academy at West Point.

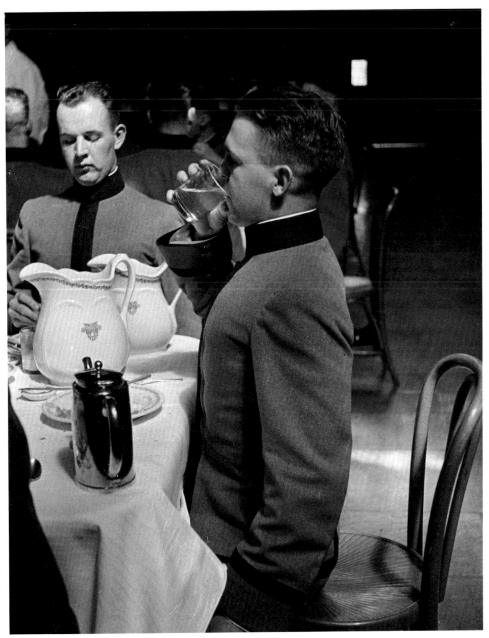

HAZING AT THE UNITED STATES MILITARY ACADEMY, WEST POINT, 1936

This one shows first-year students eating at attention.

In 1937, the executive editor of Life *was Daniel Longwell,
who gave me the assignment at Roosevelt Hospital. I am often
asked if editors tell photographers exactly what to shoot. At* Life
*the photographer was an individualist, and he could photograph
anything he wanted to. Nobody told him anything. But
Longwell had one wish about the hospital story. "Alfred,"
he said, "you can do anything, but I don't want to see
any blood." How different from* Life *today.*

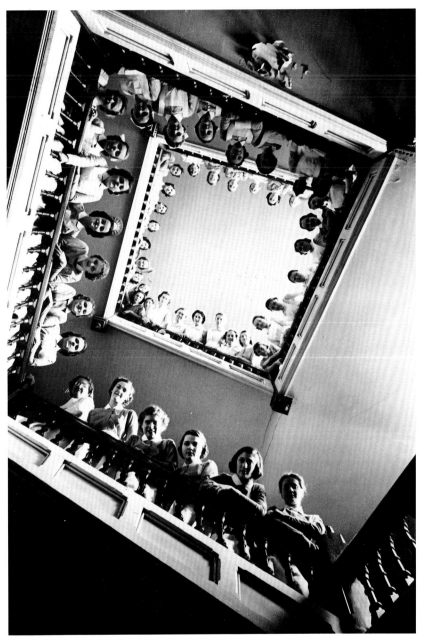

NURSES AT ROOSEVELT HOSPITAL, NEW YORK CITY, 1937

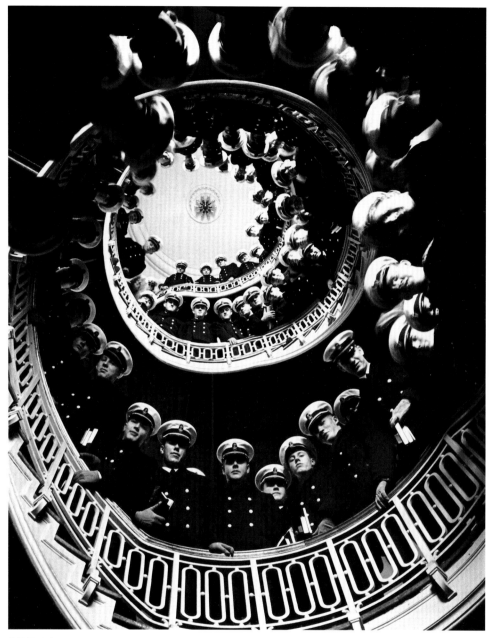

CADETS AT THE UNITED STATES NAVAL ACADEMY, ANNAPOLIS, 1936

An earlier group shot also benefited from a dramatic staircase.

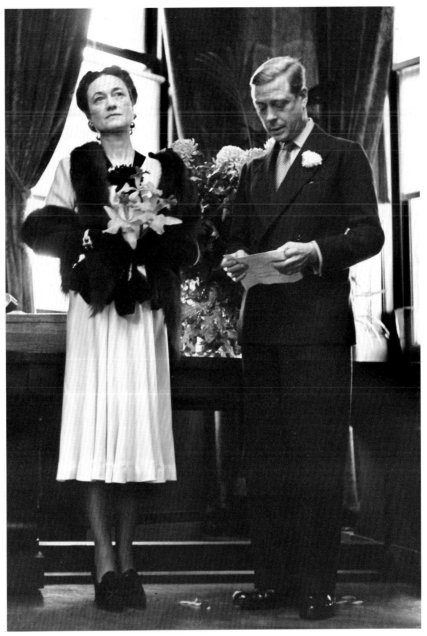

THE DUKE AND DUCHESS OF WINDSOR, BALTIMORE, 1938

I photographed the Duke and Duchess of Windsor two years after his abdication as King of England where she was born.

I occasionally did less serious pictures, including a story of women's underwear in a department store for Life. *You learn something from every picture you take.*

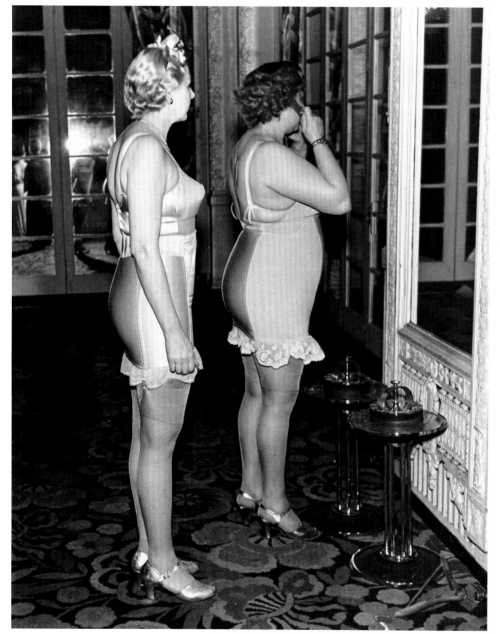

NEW YORK CITY, 1937

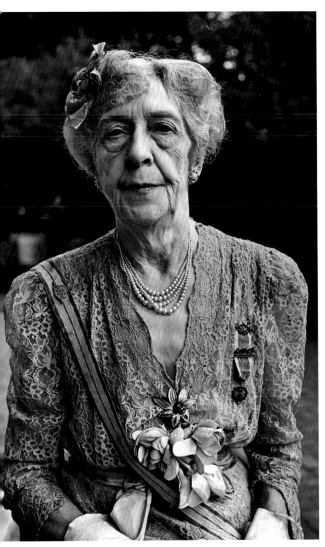

MRS. BUN WYLIE, ATLANTA, 1944

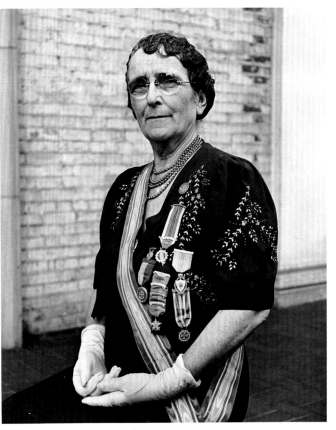

MRS. CLARENCE DI TEDO, ATLANTA, 1944

At a meeting of the Daughters of the American Revolution, these ladies, covered with medals and ribbons, seemed to represent the membership.

Obviously, the extravagant hat was what struck me here . . .

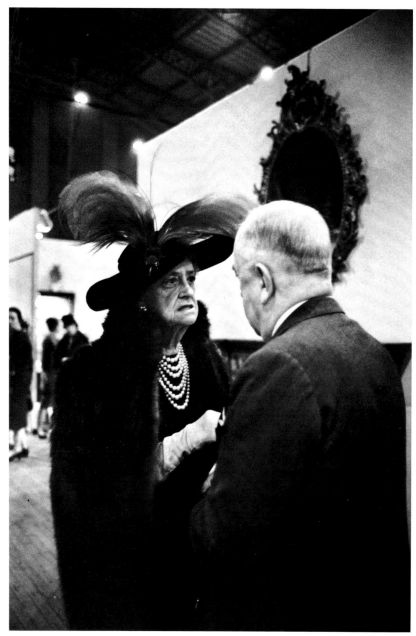

ANTIQUES FAIR, NEW YORK CITY, 1958

and the proud walk here of a woman strutting in the Tuileries Gardens.

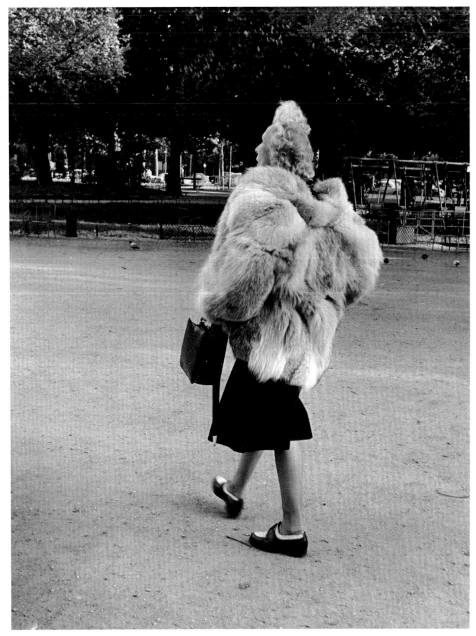

PARIS, 1963

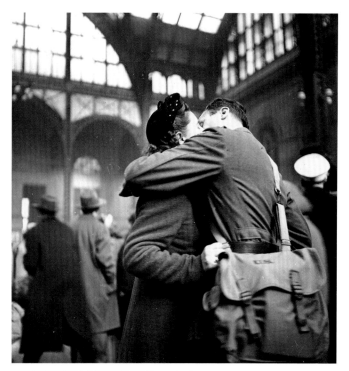

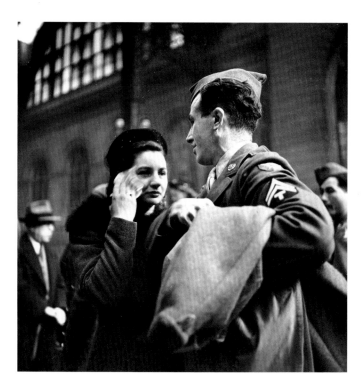

PENNSYLVANIA STATION, NEW YORK CITY, 1944

*To photograph American soldiers saying farewell to their wives and
sweethearts, I used a Rolleiflex 2¼ x 2¼, not a Leica, because
you can hold a Rolleiflex without raising it to your eye; so they didn't
see me taking the pictures. I just kept motionless like a statue. They
never saw me clicking away. For the kind of photography I do, one
has to be very unobtrusive and to blend in with the crowd.*

PENNSYLVANIA STATION, NEW YORK CITY, 1944

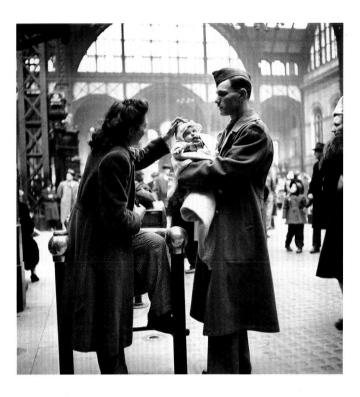

In Times Square on V.J. Day I saw a sailor running along the street grabbing any and every girl in sight. Whether she was a grandmother, stout, thin, old, didn't make any difference. I was running ahead of him with my Leica looking back over my shoulder. But none of the pictures that were possible pleased me. Then suddenly, in a flash, I saw something white being grabbed. I turned around and clicked the moment the sailor kissed the nurse. If she had been dressed in a dark dress I would never have taken the picture. If the sailor had worn a white uniform, the same. I took exactly four pictures. It was done within a few seconds.

Only one is right, on account of the balance. In the others the emphasis is wrong—the sailor on the left side is either too small or too tall. People tell me that when I am in heaven they will remember this picture.

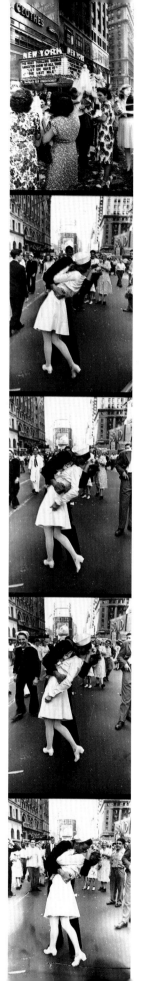

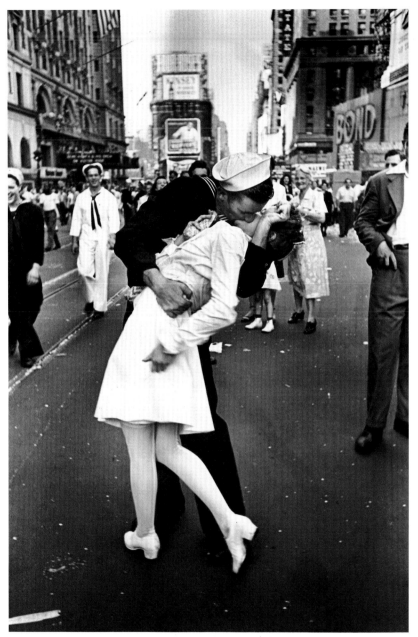

V.J. DAY AT TIMES SQUARE, NEW YORK CITY, AUGUST 15, 1945

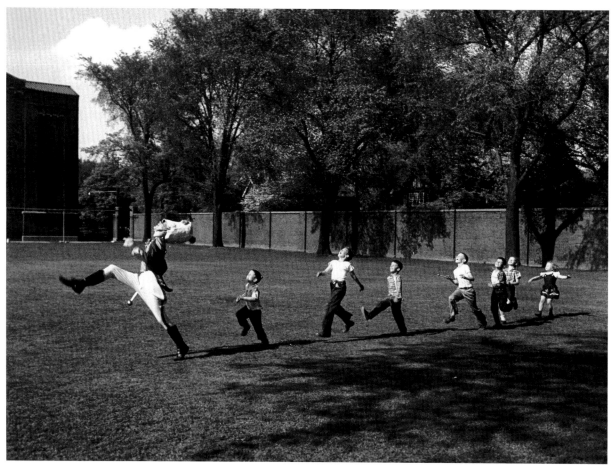

UNIVERSITY OF MICHIGAN, ANN ARBOR, 1951

Another picture I hope to be remembered by is this one of the drum major rehearsing at the University of Michigan. It was early in the morning, and I saw a little boy running after him, and all the faculty children on the playing field ran after the boy, and I ran after them. This is a completely spontaneous, unstaged picture.

I was at the Metropolitan Opera at the 200th performance of ▷
Tristan und Isolde. *Backstage was this very stout man, the great Wagnerian tenor, strapped in a corset. He didn't mind my taking his picture at all.*

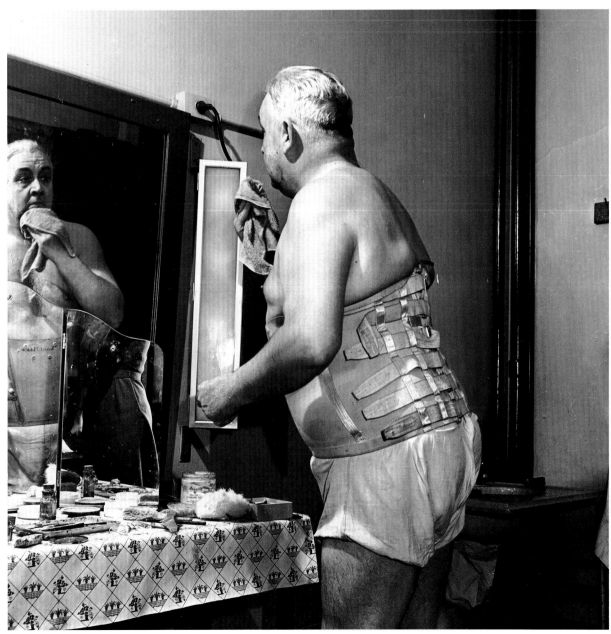

LAURITZ MELCHIOR, NEW YORK CITY, 1952

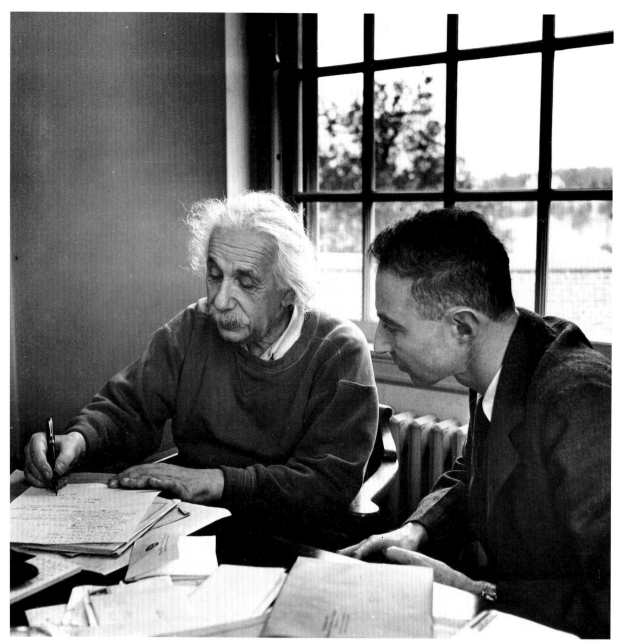

ALBERT EINSTEIN AND J. ROBERT OPPENHEIMER, PRINCETON, NEW JERSEY, 1947

I was so excited about photographing these two great scientists that I at first forgot to put film in my camera. When I discovered it, I sneaked out pretending that something was wrong with my camera.

This wasn't the first or last time that I was carried away by excitement. I wanted to have more pictures of Einstein, and Oppenheimer said, "I can't help you there, you are on your own." But I got my picture—it has never been published before. It shows Einstein lecturing to the greatest physicists in the world.

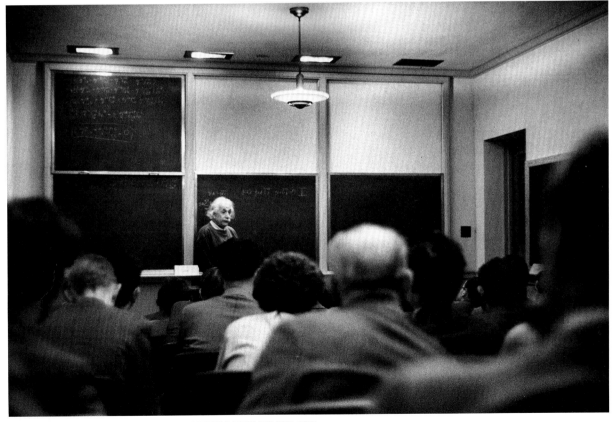

INSTITUTE FOR ADVANCE STUDY, PRINCETON, NEW JERSEY, 1947

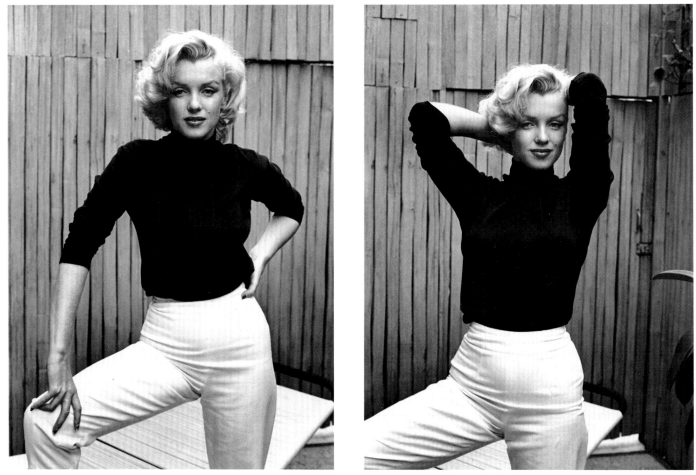

MARILYN MONROE, HOLLYWOOD, 1953

When I photographed Marilyn Monroe, I also made a mistake. I mixed up my cameras—one had black-and-white film, the other color. I took many pictures. Only two color ones came out all right. The two here are black and white.

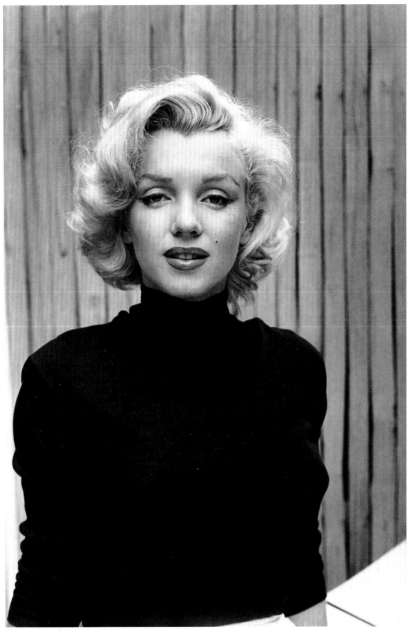

MARILYN MONROE, HOLLYWOOD, 1953

My favorite picture of Marilyn hangs always on the wall in my office.
It was taken on the little patio of her Hollywood house.

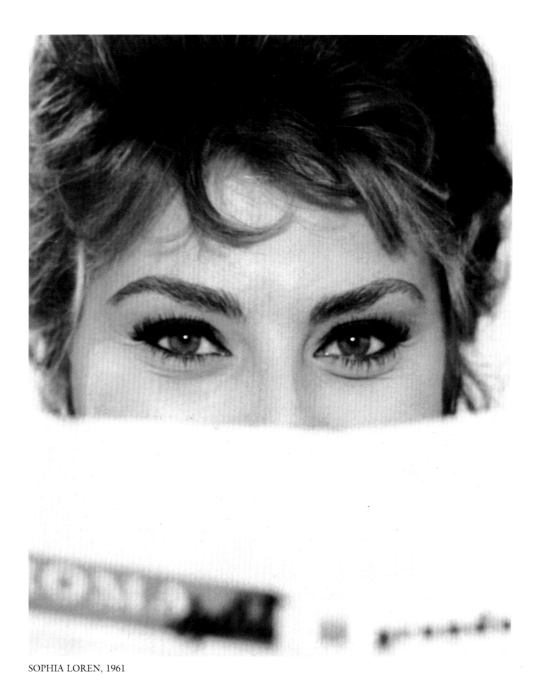

SOPHIA LOREN, 1961

It hangs next to one of another actress who is a great friend—Sophia Loren. I am always surrounded by her pictures.

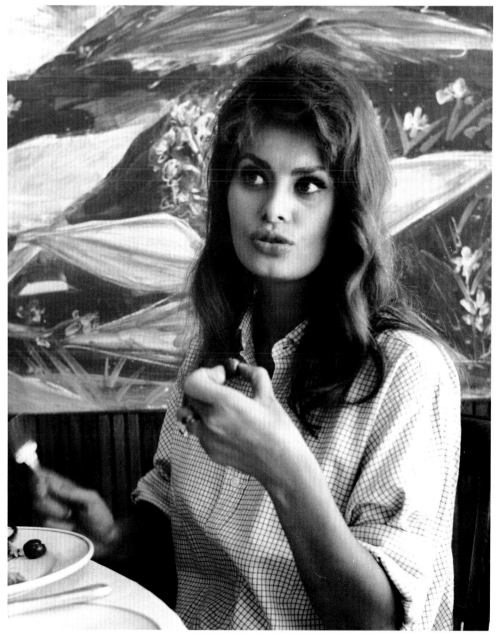

SOPHIA LOREN, ISTIA, 1961

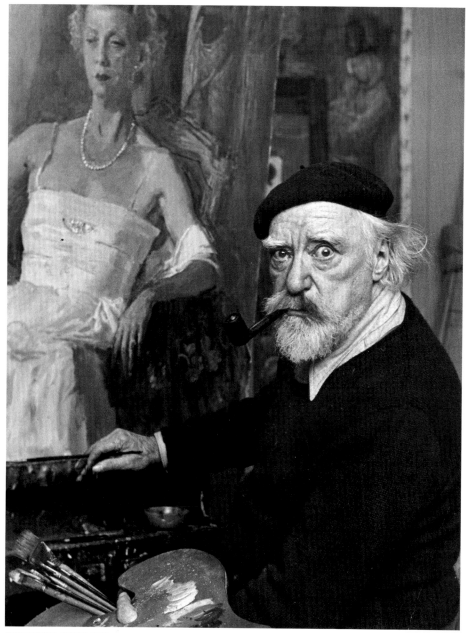

AUGUSTUS JOHN, HAMPSHIRE, GREAT BRITAIN, 1951

In the 1950s, there were many trips—to Kenya, Ethiopia, Surinam, Ghana, and elsewhere. I also went to England to do a series of portraits of distinguished Englishmen. In less than twelve days I photographed twenty-eight people. Among them was the painter Augustus John, his piercing eyes staring directly at the camera. This picture was used on the cover of Life.

I wanted to photograph the composer Ralph Vaughan Williams but he refused, which I regret. But I photographed T. S. Eliot in the small office he had occupied for twenty-five years. He admired my acrobatic skill, because I crawled under the table to get a better picture. I didn't want to shoot him against the light.

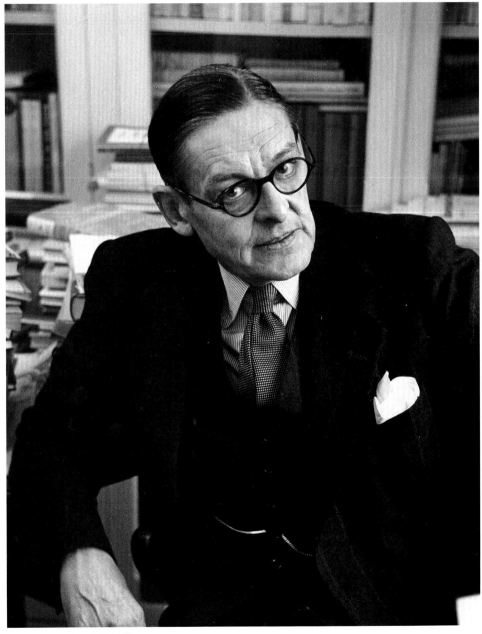

T. S. ELIOT, LONDON, 1951

I always tried to make portraits that showed the person in his natural environment. For Sir Alexander Fleming, who won the Nobel prize for discovering penicillin, I only used one little light, and I remember I had to carry a variety of plugs because the English then had different, mostly antiquated light outlets in their homes and offices.

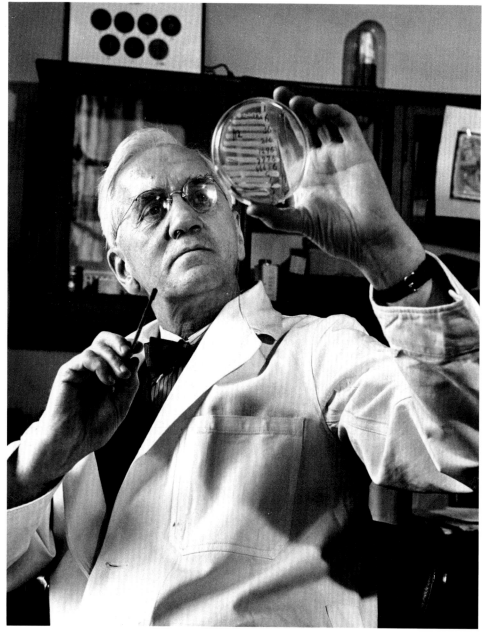

SIR ALEXANDER FLEMING, ST. MARY'S HOSPITAL, LONDON, 1951

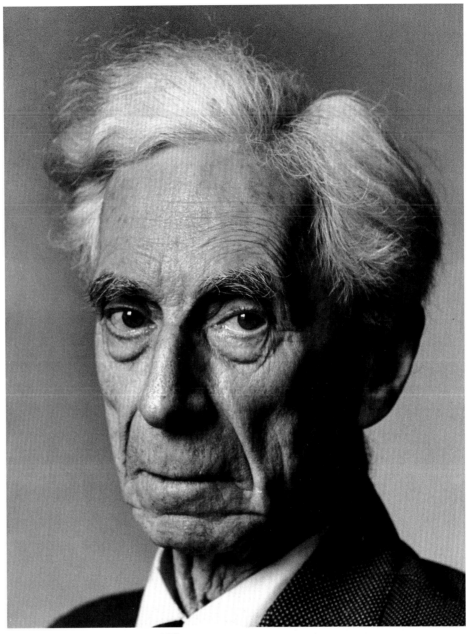

BERTRAND RUSSELL, LONDON, 1951

One picture I like very much is that of the philosopher Bertrand Russell. I told Russell that I admired his stony face. "How do you manage to keep your face so still?" I asked. "A crocodile moves very slowly," came the answer.

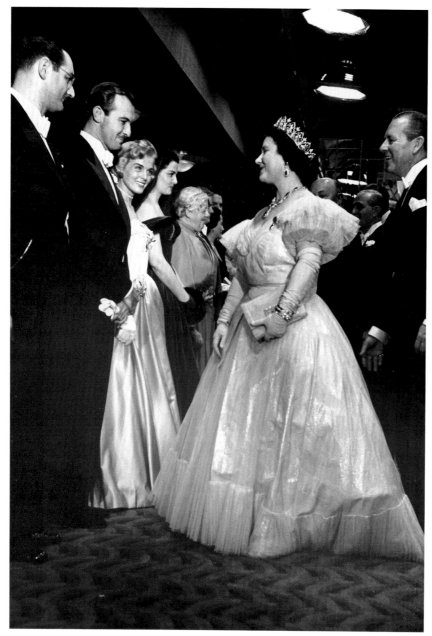

QUEEN ELIZABETH, LONDON, 1951

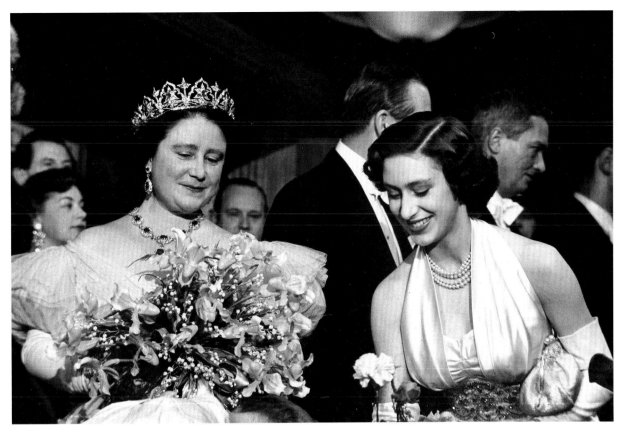

QUEEN ELIZABETH AND PRINCESS MARGARET, 1951

◁ *At a Royal Command Performance of the film,* Where No
Vultures Fly, *I photographed Queen Elizabeth—now the Queen
Mother—talking to Zachary Scott. Next to him are Lizbeth
Scott, Jane Russell, and Margaret Rutherford.*

*Princess Margaret attended the same Command Performance with
her mother.*

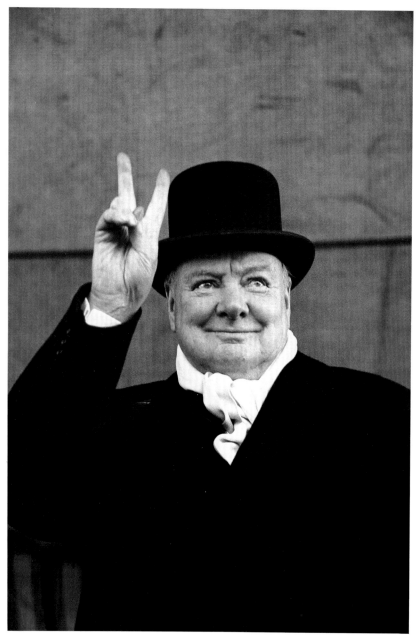

WINSTON CHURCHILL, LIVERPOOL, 1951

While in England I also covered the election campaign of the Conservative Party and traveled with Churchill for several days. He became prime minister two weeks after this picture was taken. In Liverpool I caught him dozing a little on the dais before his speech. When the band started to play the National Anthem, his son Randolph tapped him on the shoulder and up shot his fingers like a viper.

My most difficult subject was Ernest Hemingway. He was very excitable, but in the end we got on fine. It all started when I took some pictures of him in the harbor of Cojima near his home in Cuba. He went almost berserk because, while I was photographing, he overheard a little boy ask his father, "Who is that actor?" A year later I covered a deep-sea fishing contest in which he steered his own boat.

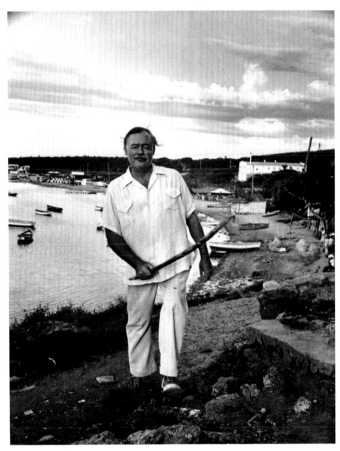

ERNEST HEMINGWAY, CUBA, 1952

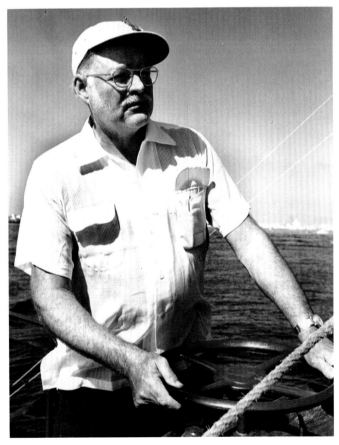

ERNEST HEMINGWAY, DEEP-SEA FISHING CONTEST, HAVANA, 1953

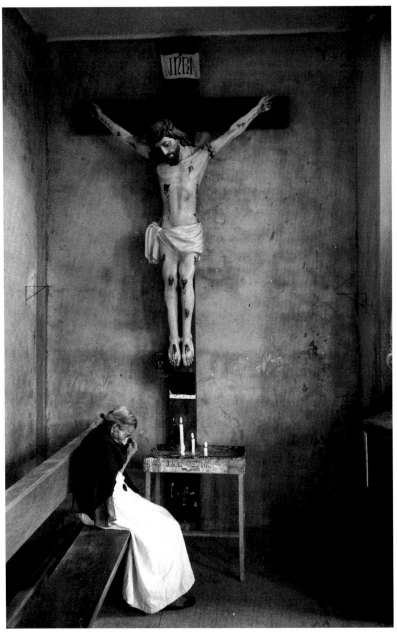

GUAYAQUIL, ECUADOR, 1958

I saw an old Indian woman sitting at a shrine. I am rarely satisfied with a general view. With one detail you can tell a more immediate story.

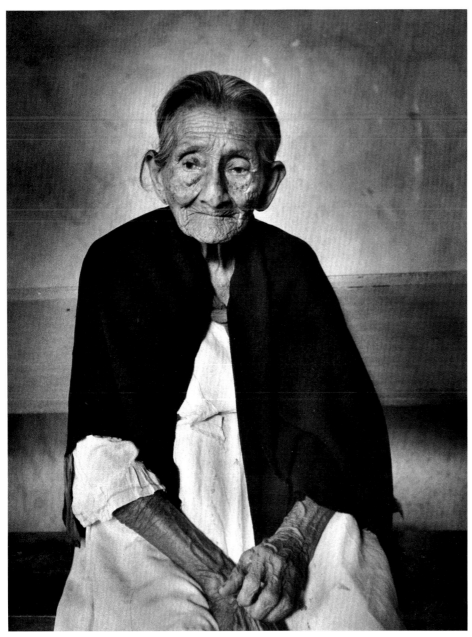

GUAYAQUIL, ECUADOR, 1958

Then I asked if I could photograph her closer. A picture of strange serenity.

I found a Talmudic scholar in a Jerusalem ghetto, but he didn't want to pose on account of his belief. But he was kind and said, "Come to my home later. I will consult the Bible, and if the Bible tells me I can, I will do it." I came back that night, and the scholar went with closed eyes to the library and opened a Bible. Then, opening his eyes, he said, "I can do it." He had seen some words from Genesis. "And they shall dance before my eyes."

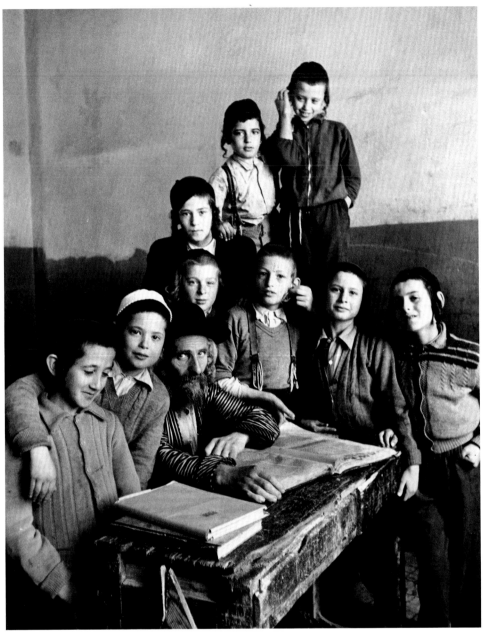

TALMUDIC SCHOLAR WITH PUPILS, JERUSALEM, 1953

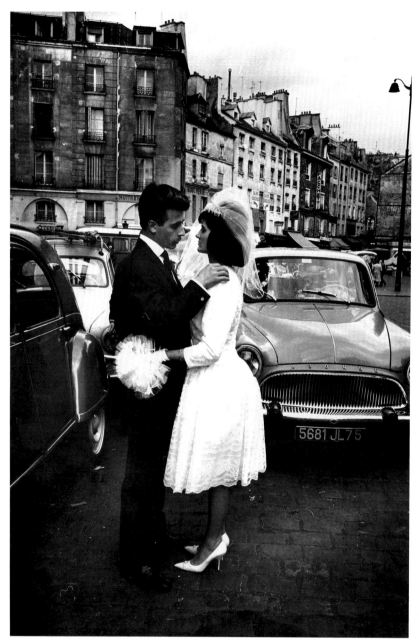

WEDDING, PARIS, 1963

When I did a series of photographs in Paris several years ago, the editor wanted to call them "Eisenstaedt's Paris." "Well," I said, "this is an awful title," but I went there with an interpreter. Every time I raised my camera, she said, "Cartier-Bresson has taken this, Capa has taken that, Brassaï had done this," and so on. So I said, "There are only two possibilities: either I go home or I kill myself, so let me do what I want." I did. The series was simply called "The Parisians."

It is always a challenge to take pictures unobtrusively. You have to study the environment to get the right angle. Patience is very important.

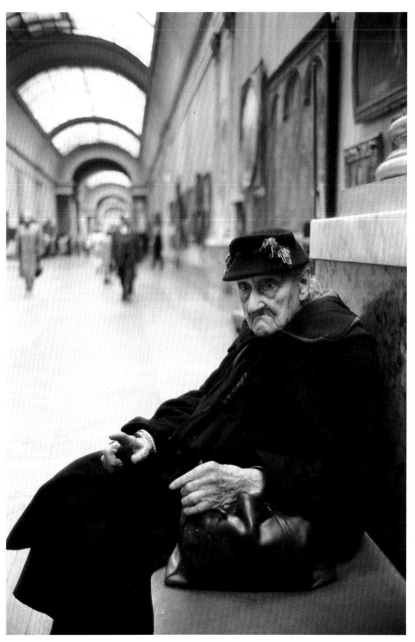

AN 89-YEAR-OLD MINIATURE PAINTER AT THE LOUVRE, PARIS, LOOKING IN THE DIRECTION OF THE *MONA LISA*, 1963

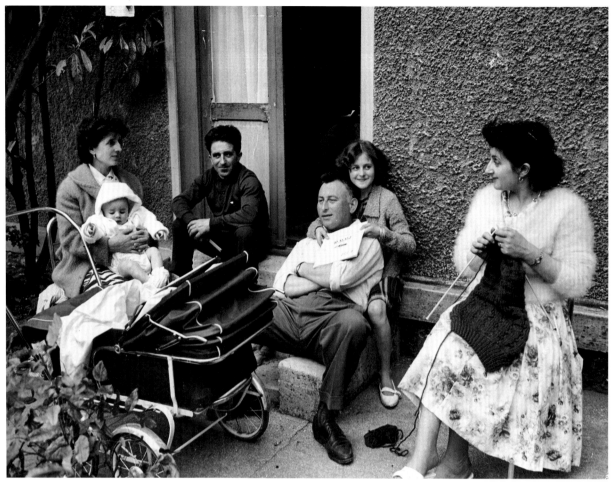

SUNDAY AFTERNOON, PARIS, 1963

The Sunday afternoon of a typical Paris concierge. I waited, focused, waited again for several minutes, then—remember, I always behaved like an amateur with little equipment—click, it was done.

―――――――

One man stuck his tongue out. He did it in spite, but I was amused. ▷

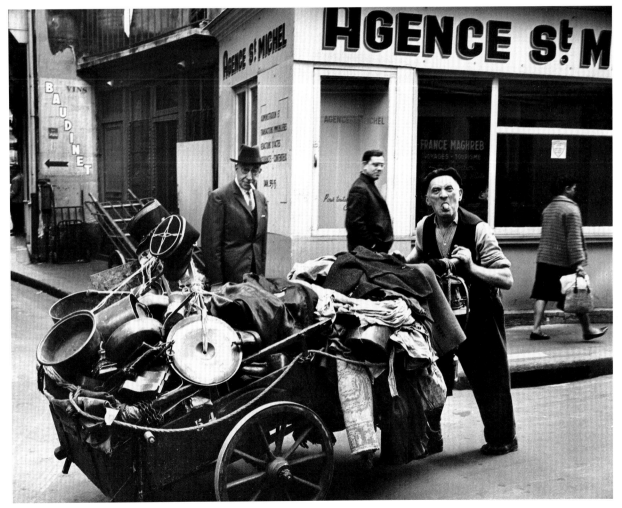

PARIS, LEFT BANK, 1963

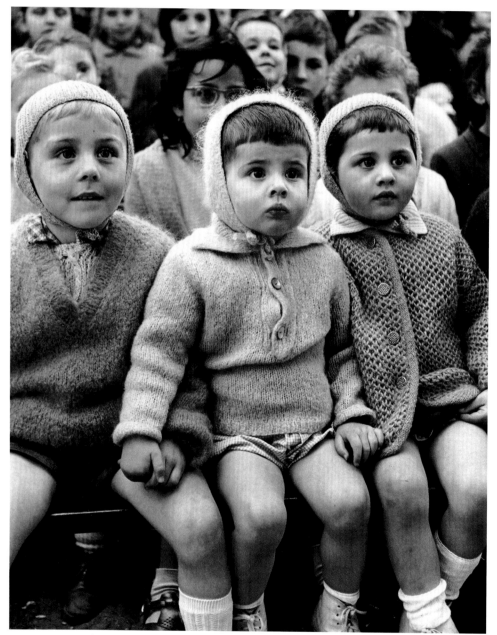

PARIS, 1963

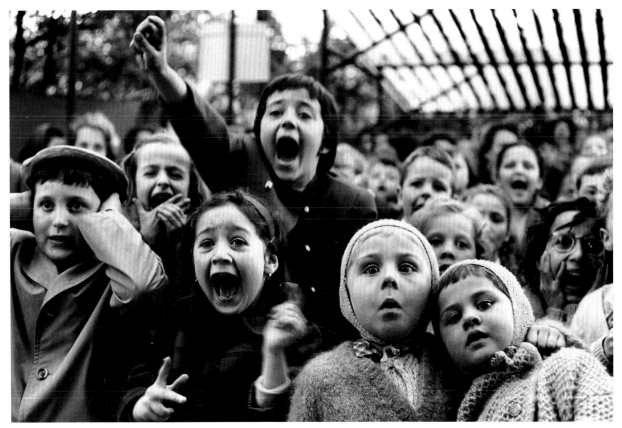

PARIS, 1963

◁ *A puppet theater in the Tuileries. It took a long time to get the*
angle I liked. There are some close-ups of the children that are good.

But the best picture is the one I took at the climax of the action. It
carries all the excitement of the children screaming, "The dragon is
slain!" Very often this sort of thing is only a momentary vision, my
brain does not register, only my eyes and my finger react. Click.

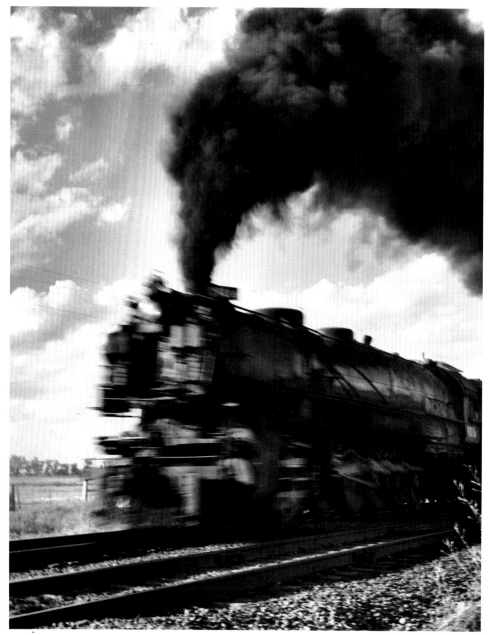

STEAM ENGINE OF THE SOUTHERN RAILROAD SYSTEM, 1938

People will look at some of my pictures like relics of the past. Here is an old steam engine in the 1930s. Ten or twenty years from now no one will know how a steam engine looks. Today they are all diesel-powered, and they look so dead.

And what will they make of the Mississippi River boats I took? . . .

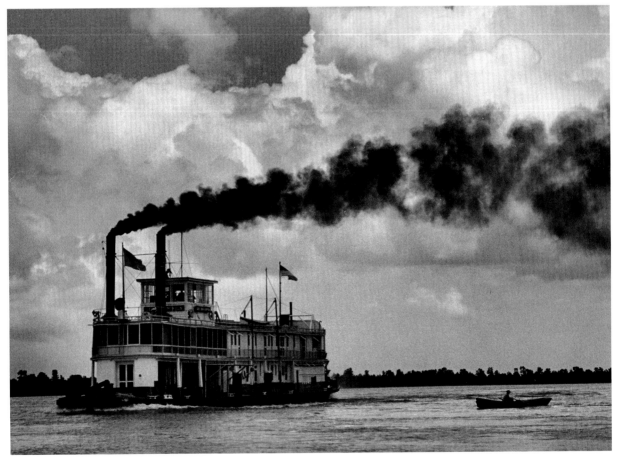

MISSISSIPPI RIVER BOAT, 1952

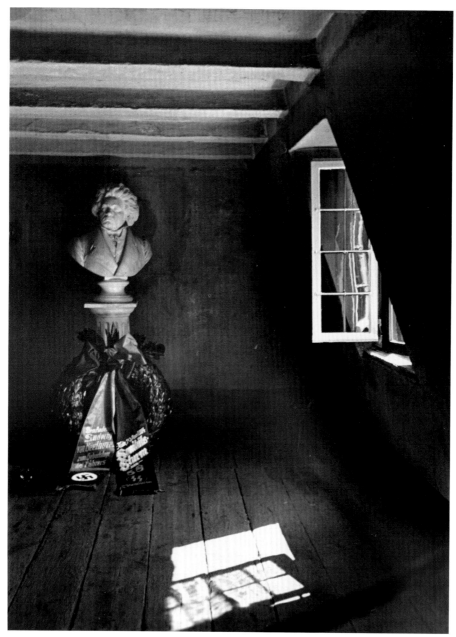

THE ROOM IN WHICH BEETHOVEN WAS BORN, BONN, 1934

In 1979 I went back to Germany to take some additional photographs for a book of mine on Germany. The earlier pictures were taken over a span of many years. Now I was supposed to do a series in a short time. Then there were the memories of the place I'd had to leave. I took this picture of Beethoven's birthplace a year before my departure from Germany. I simply wanted a picture of the famous Beethoven bust, but as I was putting up my tripod some Nazis came in and put a wreath there that read, "On the Führer's birthday—the S.S. Sturmgruppenführer, Bonn."

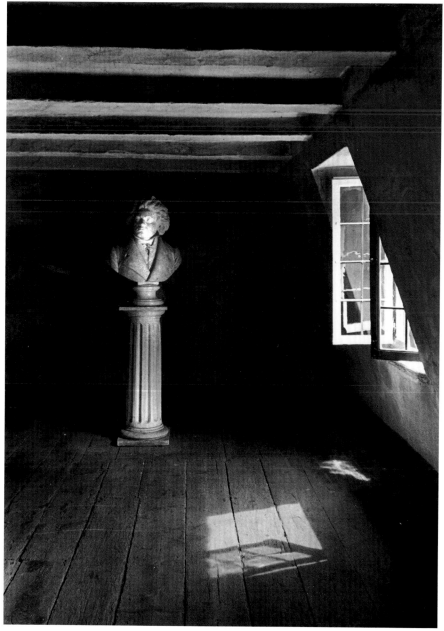

BONN, 1979

Well, I did it without the wreath when they were gone.

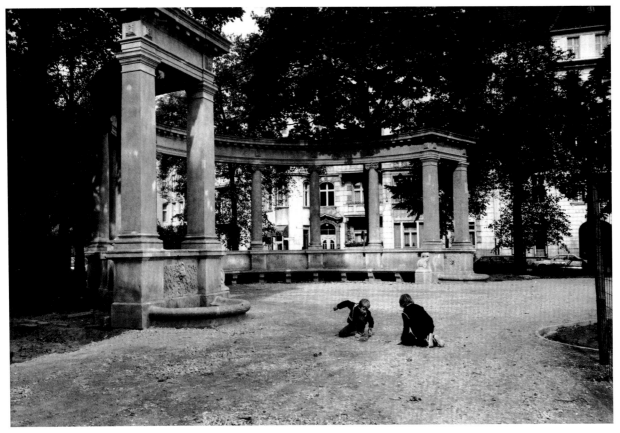

BERLIN, SEPTEMBER 1979

Much had been destroyed in Germany by the time I returned in 1979, but I found the place where I had lived in Berlin—near the Viktoria Luise Platz—exactly as I remembered it. And I found the two boys playing marbles like I used to do.

I saw many young people, and they all seemed to be not much different from the young people in America or anywhere in the world. The older people seemed to be like they always were—not as flexible, more in the old style. I also found my school, the Hohenzollern Gymnasium, now called the Riesengebirgs Ober Realschule. I remember the entrance and the yard we played in and the sandwiches my parents gave me to eat. I went inside and met the principal. He was in slacks with an open shirt. He looked so different from my teachers of fifty, sixty years ago with those stiff collars. When you met them, you almost had to stand at attention.

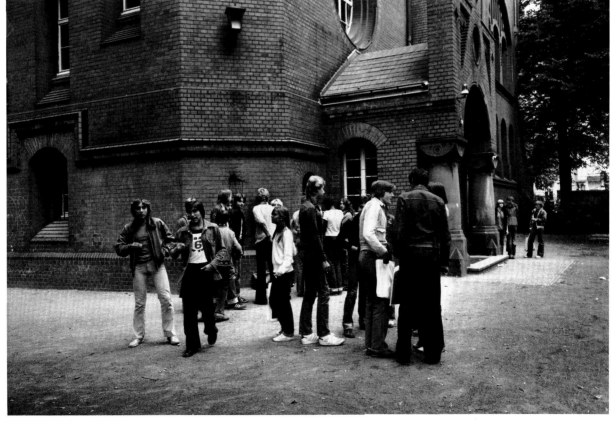

BERLIN, SEPTEMBER 1979

*And I found a strange scene. When the war broke out, Hitler
buried the old statues that stood along the Allee of Victory in Berlin
to protect them from damage. Now they were taken out of their
hiding places. There they lay tumbled—Frederick the Great,
Barbarossa—all those heroes of Germany's past.*

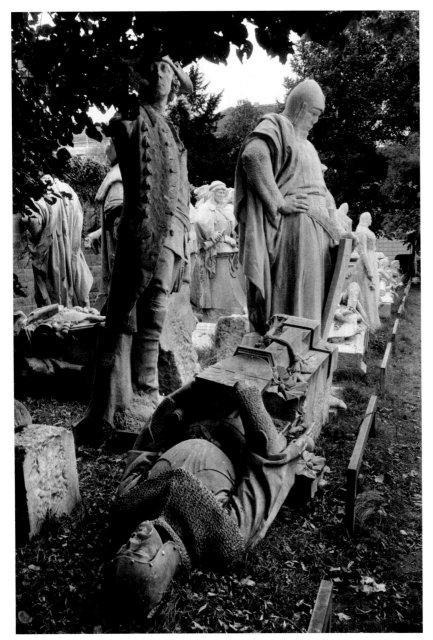

GARDEN OF BELLEVUE CASTLE, WEST BERLIN, SEPTEMBER 1979

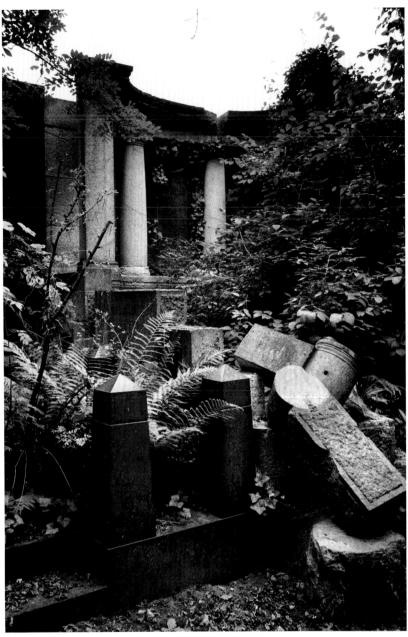

JEWISH CEMETERY IN WEISSENSEE, EAST BERLIN, 1979

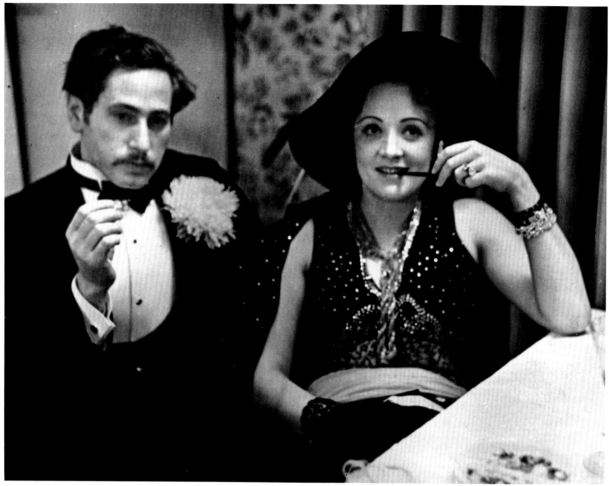

MARLENE DIETRICH WITH THE DIRECTOR JOSEPH VON STERNBERG, BERLIN, 1928

*As a companion piece to the picture I took of Marlene Dietrich with
her director Joseph von Sternberg after the filming of* The Blue Angel . . .

I photographed Marlene's successor, Hanna Schygulla, and the director Rainer Werner Fassbinder making the film Berlin Alexanderplatz. *Compare the elegance and formality of Sternberg with Fassbinder.*

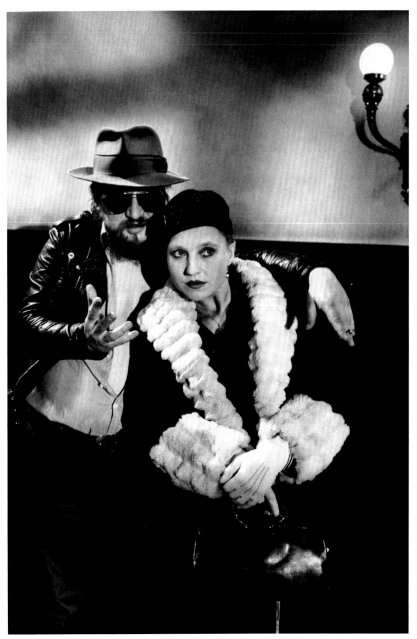

RAINER WERNER FASSBINDER AND HANNA SCHYGULLA, MUNICH, 1980

My style hasn't changed much in all these sixty years. I still use, most of the time, existing light and try not to push people around. I have to be as much a diplomat as a photographer. People often don't take me seriously because I carry so little equipment and make so little fuss. When I married in 1949, my wife asked me, "But where are your real cameras?" I never carried a lot of equipment. My motto has always been, "Keep it simple."

Chronology

1898
Born December 6 in Dirschau, West Prussia (now part of Poland), one of three sons of Regina and Joseph Eisenstaedt, a well-to-do merchant.

1906
Moves with his family to Berlin.

1912
Given his first camera—an Eastman Kodak Folding Camera No. 3 with roll film. During pre-War period attends Hohenzollern Gymnasium and receives baccalaureate.

1916
Drafted into German Army, interrupting university education. Stationed at Naumburg a/S with 55th Artillery Regiment. Wounded April 12, 1918. During his year-long recuperation, his interest in photography is renewed.

1918–25
Works as salesman of belts and buttons for Berlin wholesaler, a friend of his father's; takes photographs in his spare time.

1925
Buys Zeiss Ideal camera with Tessar f4.5 lens. Father dies; German inflation wipes out family savings.

1927
Sells one of his photographs for the first time, to *Der Welt Spiegel,* the illustrated weekly.

1928
Adopts Ermanox camera with 1¾ x 2½ inch glass plates. Begins free-lance work for Pacific and Atlantic Photos' Berlin office.

1929
Pacific and Atlantic Photos (taken over by Associated Press in 1931) gives him his first major assignment, to cover the Nobel prize ceremonies in Stockholm, in which Thomas Mann wins the prize for literature.

1930–34
Travels throughout Europe and Great Britain on assignment: photographs cultural and social events—theater performers and performances; conductors and musicians; the winter season in St. Moritz; international political conferences in Geneva, Lausanne, The Hague. 1933—covers the first meeting of Hitler and Mussolini, in Venice; the funeral of German president Paul von Hindenburg in Tannenberg; Hitler's first appearance in the uniform of the Führer. From 1932—uses Plaubel Makina camera with 6 x 9 cm sheet film and an Anticomar lens, a Leica, and a Miroflex folding camera with 6 x 9 cm sheet film. Aware of photojournalism of Martin Munkacsi and Dr. Erich Salomon; works with latter on several political assignments.

1935
Buys twin-lens Rolleiflex camera with 6 cm-square roll film, uses it intermittently into late 1950s. On his first trip to Ethiopia, photographs Emperor Haile Selassie in special audience and in preparation for war between Italy and Ethiopia. Emigrates to the United States.

1936
Works on two dummies for proposed *Life* magazine. Joins just-founded *Life* with Margaret Bourke-White, Thomas McAvoy, and Peter Stackpole as the first staff photographers; five photographs in first issue of November 23; cover story on West Point appears in second issue. Continues as staff photographer—working almost exclusively for *Life* until it was discontinued in 1972. Lives in New York.

1937–39
Does photo-essays on American universities, schools, and hospitals; Martha's Vineyard and Nantucket, among other subjects.

1940–46
As an alien, cannot be sent to cover World War II, so photographs celebrities and covers the home front for *Life*. 1942—becomes an American citizen. 1944—photographs Truman's election as Vice-President at Democratic Convention. 1945—famous photograph of V.J. Day in Times Square, New York; photographs Roosevelt's funeral. End of 1945—begins four-month visit to Japan. 1946—on trip with Emperor Hirohito, photographs Hiroshima and Nagasaki five months after dropping of A-bomb, the indictment of Japanese war criminals, and the devastation of Tokyo and Yokohama.

1947
Photographs Einstein and Oppenheimer at Princeton's Institute for Advanced Study, Italy and Czechoslovakia during rise of Communism. Does photo-essays on Charles University in Prague and St. Moritz, Switzerland.

1949
Marries Alma Kaye-Zlotnick, known as Kathy, a South African he met in New York.

1951
Photographs distinguished Britons in Great Britain and the royal family for the first time; covers Churchill's campaign and reelection as prime minister; photographs him giving famous "V for Victory" sign. Photographs General Douglas MacArthur in Korea. Receives Photographer of the Year award from Encyclopedia Britannica Book of the Year and University of Missouri School of Journalism.

1952
Does photo-essay on Ernest Hemingway in Cuba—"The Old Man and the Sea." Covers Eva Peron's funeral in Buenos Aires, presidential election on Dwight D. Eisenhower.

1953
Photographs Marilyn Monroe in Hollywood, Kenya and imprisoned Jomo Kenyatta during Mau-Mau rebellion, Dr. Kwame Nkrumah of Ghana, then the British territory the Gold Coast. Does photo-essay on Surinam's rain forest. Receives Clifton C. Edom Award from Kappa Alpha Mu, a national journalists' fraternity headquartered at University of Missouri School of Journalism.

1954
First one-man exhibition, International Museum of Photography at George Eastman House, Rochester,

New York. Photographs Senator Joseph McCarthy during McCarthy-Army hearings and a trip of the Duke of Edinburgh to the Arctic Circle.

1955
Photographs events surrounding twenty-fifth anniversary of Haile Selassie's rule in Ethiopia. Does photo-essays on Vice President Richard M. Nixon's visit to Central America; on Judaism for *Life*; on world theologians and intellectuals for *Time* magazine. Exhibition in Time-Life Building, New York.

1956
Covers Margaret Truman's wedding, the Democratic National Convention.

1957
Does photo-essay on Galapagos Islands.

1958
In international poll conducted by *Popular Photography* magazine of photographers, editors, art directors, critics, and teachers, chosen "one of the world's ten great photographers."

1959
Does photo-essay on fellow *Life* photographer Margaret Bourke-White; photographs Khrushchev's visit to United States, Bolshoi Ballet in New York.

1960
Photographs New York Governor Nelson Rockefeller on trip to Venezuela and Massachusetts Senator John F. Kennedy and wife, Jacqueline.

1961
Photographs Kennedy's inauguration as president. Presented with Leica No. 1,000,001; uses it to take official portrait of Kennedy as president; uses Leica and Nikon cameras thereafter. Photographs Sophia Loren for first time, Joan Sutherland's debut at the Metropolitan Opera in *Lucia di Lammermoor.*

1962
Awarded Culture Prize by German Society for Photography, Cologne.

1963
Photographs on trips to India and Sri Lanka; photographs Kennedy five months before his assassination. Exhibition at the Smithsonian Institution Section of Photography, Washington, D.C.

1964
Does photo-essays on Marjorie Merriweather Post, Sophia Loren's villa, people of Paris, among other subjects.

1965
Photographs pianist Vladimir Horowitz's first United States recital after his return from twelve-year retirement. Does photo-essay on Happy Rockefeller.

1966
One-man exhibition "Witness to Our Time" opens at Time-Life Building, circulates throughout United States. Book of same title featuring 416 photographs published by the Viking Press. Photographs on trip to Kenya; does photo-essay on Norway.

1967
Does photo-essays on conductors in United States and Europe and on Catholicism. Receives International Understanding through Photography Award from Nikon Nippon Kogagu, Japanese camera manufacturing company.

1968
Does photo-essays on pollution of Great Lakes, presidential candidate Richard M. Nixon at home.

1969
Photographs Nixon's inauguration, Sophia Loren and her baby, maiden voyage of S.S. Queen Elizabeth II (QE 2). *The Eye of Eisenstaedt*, featuring 181 photographs, published by the Viking Press.

1970
Photographs Vice-President Spiro Agnew and Nixon cabinet. *Martha's Vineyard*, featuring eighty-one photographs, published by the Viking Press. Now works under contract to *Life*, after thirty-four years on its masthead.

1971
Receives Joseph A. Sprague Memorial Award from the National Press Photographers Association. *Witness to Nature*, featuring 122 photographs, published by the Viking Press. Portrayed in "The Photographers" video produced by *Life* editors, screened on Alcoa Hour.

1972
Wimbledon: A Celebration, featuring 105 photographs, published by the Viking Press. His wife dies; his sister-in-law, Lucille Kaye, eventually becomes his companion.

1973
Photographs on trip to Brazil sponsored by Varig Airlines and on trip to Bermuda. *Eisenstaedt—People*, featuring 388 photographs, published by the Viking Press.

1974
Does photo-essay on Shakers for *Smithsonian Magazine*.

1976
Photographs novelist Saul Bellow, Nobel Prize winner. Exhibition at Knoedler Gallery, New York. *Eisenstaedt's Album*, featuring 373 photographs, published by the Viking Press.

1977
Photographs several United States art schools for their educational brochures, Prime Minister Pierre Elliott Trudeau of Canada.

1978
Receives the Achievement Award of the Photographic Society of America and the Lifetime Achievement Award of the American Society of Magazine Photographers. *Eisenstaedt's Guide to Photography*, featuring 160 photographs, published by the Viking Press.

1979
Receives the Photographic Administration Award for Creative Achievement; United Technologies Corp. sponsors Eisenstaedt's return to Germany to photograph for a book and exhibition.

1980
Exhibition "Eisenstaedt—Germany" shown simultaneously at the National Collection of Fine Arts of the Smithsonian Institution and the Rheinisches Landesmuseum Bonn; 1981, this exhibition opens at International Center of Photography, New York, circulated throughout United States by Smithsonian Institution Traveling Exhibition Service. Does photo-essay in color on octogenarians for *Pegasus*, Mobil company magazine.
Eisenstaedt—Germany, featuring eighty-four photographs, published by Harry N. Abrams, Inc.

1981
Eisenstaedt—Germany wins Art Directors Club 60th Annual Merit Award. Is first to photograph President Ronald Reagan's ranch in California.

1983
Receives Honorary Doctorate of Fine Arts from Miami University, Oxford, Ohio.

1984
Eisenstaedt—Aberdeen, featuring seventy-nine photographs, published by Louisiana State University Press. Exhibition of same name shown in Aberdeen and Edinburgh, Scotland.

1986
Exhibition "Alfred Eisenstaedt: Eisie at 88" opens at the International Center of Photography. Continues his daily walks from his home in Jackson Heights, Queens, to his *Life* office at 51st Street in New York City.

1987

Receives the Progress Medal from the Photographic Society of America and the Leica Medal of Excellence. Moves to an apartment in midtown Manhattan.

1988

Eisenstaedt: Martha's Vineyard, featuring 165 photographs, published by Oxmoor House. Receives Master of Photography Award from the International Center of Photography and the Mayor's Award in Arts and Culture, New York City. *Life* Gallery of Photography celebrates his ninetieth birthday with an exhibition of his photographs.

1989

Receives National Medal of the Arts from President George Bush in a White House ceremony.

1990

Eisenstaedt: Remembrances, featuring 141 photographs, published by Bulfinch Press, Little, Brown, and Company.

1993

Photographs President Bill Clinton, Hillary Rodham Clinton, and their daughter, Chelsea, on Martha's Vineyard. Retrospective at the Circle Gallery, New York City, concludes with some of these portraits.

1994

Exhibition in Time-Life Building.

1995

August 24, dies of heart failure in Martha's Vineyard, where he had summered since 1937. He was ninety-six.